IMAGES
of America

HARRISBURG
BROADCASTING

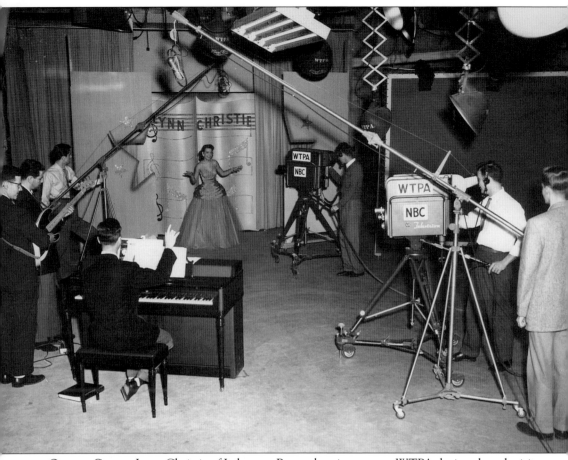

ON THE COVER: Lynn Christie of Lebanon, Pennsylvania, sang on WTPA during the television station's earliest days in the 1950s. She was accompanied by the Al Morrison Trio. In this photograph from April 1954, WTPA's Ed Baekey (left) and Don Fisher (right) operated the boom microphones, while Robin Nevitt (closest to Christie) and Fred Leuschner (middle on right) worked the cameras. (Courtesy of Betty Bryan and Fred Leuschner.)

IMAGES
of America

HARRISBURG
BROADCASTING

YVONNE,
 I HOPE THIS BOOK BRINGS BACK WONDERFUL
MEMORIES OF YOUR HUSBAND'S BROADCASTING
LEGACY IN HARRISBURG.

Timothy P. Portzline

ARCADIA
PUBLISHING

Published by Arcadia Publishing
Charleston, South Carolina

Printed in the United States of America

Library of Congress Control Number: 2010939619

For all general information, please contact Arcadia Publishing:
Telephone 843-853-2070
Fax 843-853-0044
E-mail sales@arcadiapublishing.com
For customer service and orders:
Toll-Free 1-888-313-2665

Visit us on the Internet at www.arcadiapublishing.com

For Kim, Ben, Sarah, and Andy

For Leonard and Barbara Portzline

For Isabelle Neumyer Foster

For Ruth Fiddler Portzline

For Penny Kireta Meyer (1951–2010)

CONTENTS

ACKNOWLEDGMENTS

This book—this photo album—would not have been possible without the help of a number of people. I sincerely thank everyone who contributed in any way. I would especially like to acknowledge R.J. Harris, Fred Leuschner, Jack Danner, and John Baldwin for their generous support with locating and providing photographs and research material; without them this project would never have been possible.

I would also like to recognize the Pennsylvania Museum of Music and Broadcast History for its work to preserve Pennsylvania's place in the history of radio and television.

INTRODUCTION

The advanced state of communications that we enjoy in the 21st century makes it difficult to imagine what the world was like more than a century ago before broadcasting was invented. The very nature of our society has been influenced by electronic communications. Our personal values, ideals, and attitudes have no doubt been shaped at some point by radio, television, or more recently, by the Internet. We are so accustomed to being connected that it just seems that life should have always been that way.

We didn't have transcontinental telephone service until 1915. The first televised presidential news conference only happened in 1961, which, comparatively speaking, wasn't that long ago. I can remember being fascinated as a kid when I saw the words "Live via satellite" flash across the bottom of the screen when President Nixon arrived for his historic trip to China in 1972. Today, we are so accustomed to seeing video from just about anywhere on Earth that few of us stop to recognize the tremendous scientific and technological advances that made it possible.

Maybe now would be a good time for a short history review. In the late 1800s, Italian inventor Guglielmo Marconi created the first system that used wireless communications to send simple Morse code messages. By 1906, Canadian scientist Reginald Fessenden had discovered a way to create a continuous wave radio signal that could carry the human voice. In the years that followed, electronics developed to the point where radio experimenters were popping up across the country. Some of these experimental stations went on to become the foundation for radio broadcasting around the end of World War I. By 1920, radio had developed to the point where a new class of radio service was created by the federal government, that of the commercial radio station. By 1920, there were only a small number of officially licensed radio stations. By a decade later, radio had turned into a massive industry.

As radio was gaining popularity in the 1920s, scientists like Edison and Tesla predicted that "radio vision" would eventually be possible. A number of inventions were developed toward that purpose, all with varying degrees of success. In 1939, the Radio Corporation of America, or RCA, unveiled its all-electronic television system at the New York World's Fair with an address by Pres. Franklin D. Roosevelt. Finally in 1941, the Federal Communications Commission (FCC) had settled on a national standard for television and began issuing licenses for TV stations.

Many historic events have come into our homes as the result of radio and television. President Roosevelt's declaration of war after Japan's attack on Pearl Harbor was carried nationally over the radio in 1941. The Apollo moon missions were televised live between 1969 and 1972. And more recently (and tragically), many Americans witnessed the 9/11 attacks on live television.

Through the years, many talented people made valuable contributions to the overall success of broadcasting throughout the greater Harrisburg-Lancaster–Susquehanna Valley region.

Names like Clair McCollough and Marijane Landis from WGAL, Dick and Abe Redmond from the WHP stations, Ed K. Smith from WCMB, Olin Harris from WKBO and WHP, and Bob Alexander and Dan Steele from WKBO are just a few of the people who pushed the envelope to make the history of Harrisburg broadcasting unique.

My love of radio began as a kid growing up on Harrisburg's West Shore. My brother Larry and I used to listen to the radio as we busied ourselves with hobbies in our parents' basement during the early to mid-1970s. We listened to WKBO and WFEC, the local Top 40 stations. While listening to deejays like Bob Alexander, John St. John, and others, I distinctly recall thinking that it sounded like they were having the time of their lives in front of the microphone. That's what I wanted, too. The next step was getting my foot in the door. Then along came WMSP.

WMSP (94.9 MHz) was a church-owned, 50,000-watt FM station in Harrisburg. It was operated by a staff of volunteers from a wide variety of backgrounds. My background was as a fifth-grade school kid. In 1975, after receiving several months of training, I had the rare opportunity (and privilege) of becoming one of the youngest people in the country to earn a Third Class Radiotelephone License from the FCC. (At the time, this license was the minimum requirement for anyone who operated a radio station transmitter.) My experience at WMSP gave me the chance to move on to other stations and eventually do some on-air work at Sunny 99 (WSFM) in the 1980s. My career shifted to the technical side when I became the assistant engineer for WINK 104 in 1989. After working in Virginia Beach, Virginia, for nine years, I returned to Harrisburg to be the director of engineering for Clear Channel Radio's Harrisburg cluster in 2000.

For all of its ups and downs, working in broadcasting sometimes feels like having a very large, extended family—almost like having thousands of cousins scattered across the country. There are cousins you know, cousins you don't know, and cousins you have only heard of. There are cousins with whom you get along and some who are a little more challenging. There are cousins who could easily spend hours talking about their long careers as if everything just happened yesterday, and those who are just getting started. Some cousins have gone their separate ways for one reason or another. And of course, there are the cousins who have passed away, whose stories should be preserved for future generations.

I guess this makes me a family historian! Enjoy the photographs.

One

SETTING THE STAGE

In 1920, Woodrow Wilson was president of the United States. George Hoverter was the mayor of Harrisburg, Pennsylvania. Milton Hershey was making chocolate in nearby Derry Township. The Pennsylvania capitol building was only 14 years old.

Movie theaters were big attractions throughout Harrisburg, just as they were around the country. Residents sought diversions from everyday life at their neighborhood theater, either in the form of a moving picture or a live performance. Theater owners competed with each other by presenting the best shows, having the most attractive building, or seating the most people.

Before broadcasting took off in the 1920s, immediacy was measured in newspaper editions, not minutes or seconds. The city had several newspapers at the time, including the *Harrisburg Patriot and Evening News* and the *Harrisburg Telegraph*. It often took up to a day after the news was made before headlines reached the first doorstep. The printing press ruled the flow of information, much as it had for centuries.

One of the mostly widely recognized events in the history of radio came on November 2, 1920, when KDKA in Pittsburgh transmitted the results of the Harding-Cox presidential election to anyone within range who had the necessary receiving equipment. Whether it was the significance of the national election or just good publicity from Westinghouse (the station's owner), the KDKA broadcast is generally considered to be the tipping point that launched radio as it is known today. Suddenly, theaters and newspapers had competition.

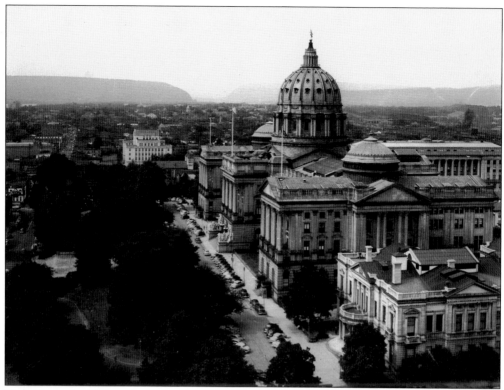

Harrisburg has been the capital city of Pennsylvania since 1812. The present capitol building was dedicated in 1906 by Pres. Theodore Roosevelt. (Courtesy of R.J. Harris; WHP photograph collection.)

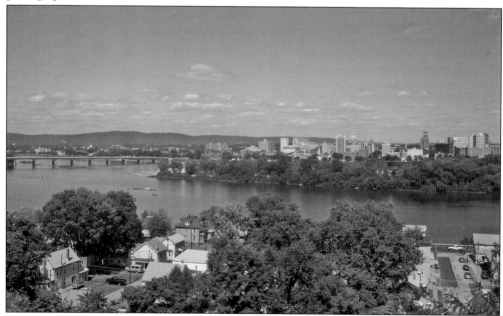

This is one of the most popular views of Harrisburg as seen from Negley Park in Lemoyne. (Photograph by Tim Portzline, 2010.)

Two

THE 1920S

According to US Department of Commerce records, the first license for a commercial land station in Harrisburg was granted to WBAK in 1922 (*DOC Radio Service Bulletin*, May 1, 1922, page 3). It was owned by the Pennsylvania State Police and managed by Col. Cecil Wilhelm. WBAK's programming consisted of police reports, lectures by state and local officials, and entertainment by local performers.

WABB, Harrisburg's second radio station, debuted in 1923 and was owned by Dr. John B. Lawrence (*DOC Radio Service Bulletin*, May 1, 1923, page 3). Lawrence operated the station from his home at 2006 Market Street. WABB carried music, speeches by local dignitaries, and at least on one occasion, an interview with a Hollywood celebrity. Lawrence himself entertained kids by reading bedtime stories.

Federal Radio Commission (FRC) publications indicate that WABB changed hands in 1924 and again in 1926. However, by April 1927, it completely vanished from FRC publications, leaving no evidence that the station had been sold a third time or that it changed call letters.

The third commercial license in Harrisburg was granted to WHBG in March 1925. It was owned by local businessman John Skane (*DOC Radio Service Bulletin*, March 2, 1925, page 3).

Skane sold WHBG to Winfield Scott "Mack" McCachren in late 1926. McCachren changed the call letters to WMBS for "Mack's Battery Service" (*DOC Radio Service Bulletin*, December 31, 1926, page 8). McCachren drew heavily upon local musical talent and the occasional major sports event for his programming.

After nearly being stripped of his license in mid-1928, McCachren sold WMBS to the Pennsylvania Broadcasting Company in early 1929. That is when the station became WHP, which stood for "Harrisburg, Pennsylvania" (*DOC Radio Service Bulletin*, March 30, 1929, page 13—"WMBS [Lemoyne, PA]—Call changed to WHP; owner, Pennsylvania Broadcasting Co.").

WPRC was the fourth station to be granted a commercial radio license in Harrisburg. It was owned by the Wilson Printing and Radio Company in October 1925. (*DOC Radio Service Bulletin*, October 1, 1925, page 3). WPRC's programming featured musical acts from the area.

WPRC was sold to Norman R. Hoffman in June 1929. Hoffman changed the call letters to WCOD (*DOC Radio Service Bulletin*, June 29, 1929, page 18). Hoffman retained WCOD for only a short time, selling the station to Keystone Broadcasting Corporation in 1930 (*DOC Radio Service Bulletin*, December 31, 1930, page 9). WCOD later became WKBO.

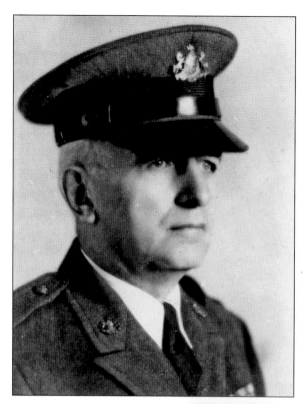

Col. Cecil M. Wilhelm of the Pennsylvania State Police (PSP) managed Harrisburg's first officially recognized broadcasting station, WBAK, during the 1920s and 1930s. Wilhelm was PSP commissioner from 1943 to 1955 and was responsible for creating the PSP's first statewide communications system in 1946. (Courtesy of Pennsylvania State Police Historical, Educational, and Memorial Center.)

WBAK's transmission facilities were located is this building at Eighteenth and Herr Streets in the city during the 1920s and 1930s. The building still stands, as seen in this modern image. Toward the end of WBAK's operation in the 1930s, the station had two freestanding towers, one on each side, approximately 50 yards from the building. (Photograph by Tim Portzline, 2010.)

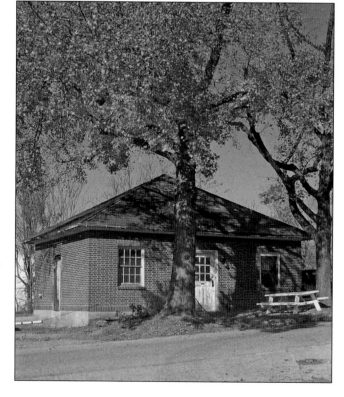

PROVISIONAL 8/22/23 – 11/01/23

No. 673

LICENSE FOR LAND RADIO STATION

CLASS C – LIMITED COMMERCIAL

DEPARTMENT OF COMMERCE
BUREAU OF NAVIGATION
RADIO SERVICE

Pursuant to the act to regulate radio communication, approved August 13, 1912,

PENNSYLVANIA STATE POLICE

a citizen of the State of _____ *** _____, a company incorporated under the laws of the State of _____ PENNSYLVANIA _____, having applied therefor, is hereby granted by the Secretary of Commerce for a period of _____ THREE MONTHS _____ on and subject to the restrictions and conditions hereinafter stated and revocable for cause by him, this License to use or operate the apparatus for radio communication (identified in the schedule hereinafter) for the purpose of transmitting to and receiving from ship stations and other land stations public correspondence, Government and service correspondence, and distress signals and messages, at rates of compensation not in excess of those fixed by the international agreement to which the Government of the United States has adhered, which have been submitted to and approved by the Secretary of Commerce, as included in the schedule hereinafter, or for the purpose of conducting experiments for the development of the science of radio communication or the apparatus pertaining thereto, to carry on special tests, using any amount of power or any wave lengths, at such hours and under such conditions as will insure the least interference with the sending or receipt of commercial or Government radiograms, of distress signals and radiograms, or with the work of other stations, the purpose of the station being designated by the classification at the head of this License.

2. Public correspondence or limited commercial correspondence authorized by this License shall be limited to certain stations, ships or lines of ships named hereinafter, which designation is authorized in view of the nature of the service and is independent of the radio system employed.

3. The use or operation of apparatus for radio communication pursuant to this License shall be subject also to the articles and regulations established by the International Radiotelegraphic Convention, ratified by the Senate of the United States and caused to be made public by the President, and shall be subject also to such regulations as may be established from time to time by authority of subsequent acts and treaties of the United States, in so far as they apply to the class of station indicated by this License.

Scanned from the original document, this is page one of WBAK's station license from August to November 1923. It is a rare glimpse of a US Department of Commerce (DOC) wireless communications license from the 1920s. According to DOC records, WBAK's original license was granted in 1922, which was the first of its kind in Harrisburg history. The license had to be periodically renewed by the Pennsylvania State Police until the station ceased operating in the 1930s. (Courtesy of John T. Shingara.)

13

SCHEDULE OF STATION AND APPARATUS

Name of owner, __Pennsylvania State Police,__

Location: State __Pennsylvania__ ; *County*, __Dauphin__

City or town, __Harrisburg__ ; *Street,* __18th & Herr__ ; *No.* **

Geographical location: Latitude, N. __40__ ° __16__ ' App."; *Longitude, W.* __76__ ° __55__ ' App."

This station is licensed for communication only with the following land stations, ships, or lines of ships:

__Limited Commercial Broadcasting, Class "C". This station is licensed for broad-
casting police information only, on the exact wave length specified. No variation
is permitted.__
__One commercial second class operator or higher required. The hours of operation
specified below may be changed or a division of time may be required, whenever in
the opinion of the Secretary of Commerce such action is necessary.__

Specific hours during which the station must/may *be open to service (local standard time):* ____

__Unlimited hours__

Power: Transformer input, __500 Watts__ XXXX

Normal day range in nautical miles, __100__

Time and method, if any, of sending time signals and hydrographic and meteorological radiograms:

Call letters, __W B A K__

____ ; *Coast charges: per word* ____, *minimum per radiogram* ____

____ ; *Coast charges: per word* ____, *minimum per radiogram* ____

____ ; *Coast charges: per word* ____, *minimum per radiogram* ____

Radiotelegraphic system employed, __Westinghouse V. T. Telephone__

Characteristics of transmitting system:

Type of spark gap, ____

Approximate spark frequency, ____

Wave length range of receiving system: From __180__ *meters to* __700__ *meters.*

Antenna: Number of masts __2__ , *Height,* ____ ***

Type of aerial, __T - Four Wire__

Wires: Number, __4__ . *Size and kind,* __7/16 Phos. Bronze__

Essential dimensions: Maximum height above water, __125__ *feet; Length of horizontal part,*
__180__ *feet; Length of vertical part,* __70__ *feet; Total length measured from apparatus,*
__160__ *feet; Length of ground connection,* ** *feet; Fundamental wave length* __300__ *meters.*

WAVE LENGTHS

The normal sending and receiving wave length shall be __600__ *meters.*

If the station be classified as a coast station it shall be prepared to transmit or relay distress calls

Prior to the creation of the Federal Communications Commission (FCC) in 1934, the US Department of Commerce was responsible for regulating wireless communications under the Radio Act of 1912, as shown in the license above. WBAK's license lists the station's owner (Pennsylvania State Police), location (Eighteenth and Herr Streets), the type of operation (limited commercial broadcasting of police information), call letters (WBAK), power level (500 watts), and details about the transmitting antenna to be used. (Courtesy of John T. Shingara.)

RADIO TO CARRY HOLLYWOOD TALE

Life in Movie Town Will Be Told by Actress From WABB Broadcasting Station

"Life of the Actors in Hollywood," told by pretty Miss Madge Bellamy, moving picture actress, will mark the official opening to-night of the broadcasting station at 2006 Market street, owned and operated by Dr. J. B. Lawrence.

Fans within the scope of its 266 meters will be able to "listen in" on the program. The call letters of the station has been changed from 3 CDO to WABB, following its admission by the Department of the Interior as a recognized broadcasting station.

The talk of Miss Bellamy will be one of three by well-known personages. Mayor Hoverter, with the address of welcome, is listed first on the program. Miss Bellamy has journeyed here expressly for the purpose of inviting the Mayor and Governor Gifford Pinchot to the Monroe Doctrine centennial at Los Angeles in July.

Dr. George Ashley, State Geologist, and third speaker on to-night's affair, will give his address on "The Living Earth." The address will be combined with organ recitals and piano solos.

Miss Bellamy has a host of admirers among movie fans who saw her play in "Lorna Doone" and "Heart of the Beast," and scores of them will tune for the program which goes into the "air" at 7.30 o'clock.

A special program has also been arranged for Monday evening when the American Legion band gives its first radio concert. Lou Cohen, local vaudeville actor, is scheduled on another program Tuesday.

Dr. John B. Lawrence put Harrisburg's second broadcast on the air in early 1923. This article from the *Harrisburg Telegraph* announced the first broadcast of WABB on April 19, 1923. The station was located at 2006 Market Street in Harrisburg. It transmitted on 266 meters (1130 kHz) with a meager power of 10 watts. (© 1923 the *Patriot-News*. All rights reserved. Reprinted and used with permission of the *Patriot-News*.)

WBAK's inaugural broadcast included interviews with Harrisburg mayor George Hoverter and actress Madge Bellamy. The lovely and cantankerous Bellamy was known for her silent films, including *Lorna Doone* in 1922 and *Soul of the Beast* in 1923. This article appeared in the April 20, 1923, edition of the *Harrisburg Telegraph*. (© 1923 the *Patriot-News*. All rights reserved. Reprinted and used with permission of the *Patriot-News*.)

NEW BROADCAST STATION OPENS

WABB Operates on 266 Meters; Sends Speeches to Central Pennsylvania Fans

Harrisburg's second official broadcasting station began operation last evening when radio station WABB, formerly 3 CDO, at 2006 Market street, sent out three speeches to the hundreds of Central Pennsylvania fans within the scope of its 266 meters. One of the best radio programs ever given in Harrisburg marked its opening and hundreds of acknowledgements were being received by its owner, Dr. J. B. Lawrence, at a late hour to-day.

Tentative plans are now underway for the selection of days on which the station will operate. So far it has been decided that programs will be given between the hours of 7 and 10 p. m. on a wave length of 266 meters. The State

Police radio station WBAK, the first of its kind established in Harrisburg will continue on its regular schedule.

"This station has been open to city and State departments as well as to worthy charity," said Dr. Lawrence in an interview to-day when asked about his plans for the future in regulating broadcasting. "I am ever glad to co-operate with the residents of Harrisburg, and, moreover, the amateurs." It is your station and it is you that I am trying to please."

Under the protection of the Department of the Interior, Dr. Lawrence now holds the privilege of reporting persons who maliciously interfere with any of the regular program of the station. Complaints received sometime ago from owners of receiving sets told of this practice. Violators have been warned and are now under strict obligation to observe the broadcasting time, under penalty of having their license revoked.

15

Second Central Pennsylvania Radio Station is Now Known as WABB

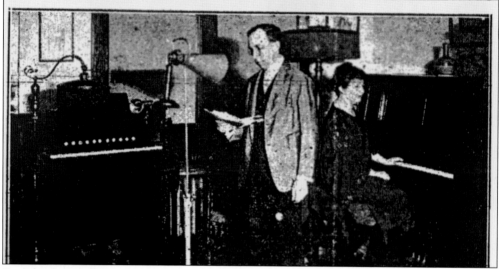

Dr. John B. Lawrence used his home as a makeshift studio for WABB, complete with a piano and organ for live performances. This photograph appeared in the *Harrisburg Telegraph* on April 27, 1923. (© 1923 the *Patriot-News*. All rights reserved. Reprinted and used with permission of the *Patriot-News*.)

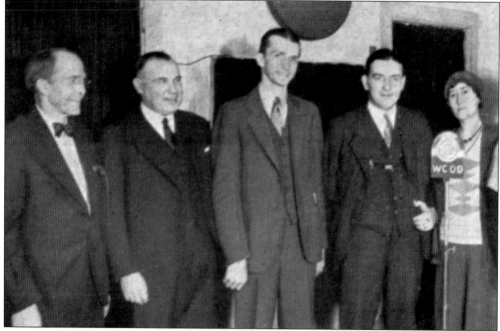

Norman R. Hoffman (center) was the owner of WCOD in 1929. (WCOD became WKBO in the 1930s.) Shown from left to right are B.F. Hoffman, E.J. McCue, Hoffman, D.A. Marshall, and Eleanor Kerchner. (Courtesy of the author's collection.)

Dr. John B. Lawrence quickly put radio behind him after only a year on the air. He sold WABB to the Harrisburg Sporting Goods Company in 1924, which then sold it to the Harrisburg Radio Company. It disappeared from Department of Commerce records by April 1927, leaving WBAK, WMBS, and WPRC to continue.

WABB REACHES MANY AMATEURS

Owner Routed From Bed to Answer Phone Calls When Fire Threatens Village

The regards with which the fans of Central Pennsylvania hold the local broadcasting station WABB, at 2006 Market street was demonstrated Wednesday evening when scores of fans from surrounding towns routed the owner; Dr. J B. Lawrence from his bed to give details on a forest fire near Elizabethville.

Dr. Lawrence had made several attempts early in the evening to get in communication with a radio operator at Elizabethville, when he learned that all wire communication with the threatened village had been destroyed by fire. Receiving scores of times by anxious fans, he was kept at the telephone until the wee small hours of Thursday morning.

Since being recognized by the Federal Government the station has been giving programs every night with the exceptions of Wednesdays and Saturdays. He will continue with the same program, operating on a wave length of 266 meters.

The above picture shows Dr. Lawrence announcing last evening's program which contained a concert by the Imperial Banjo Orchestra and several numbers by Ben Meroff and Ben Marburger, Keith vaudeville actors, playing at the Majestic this week. Below the owner is reading one of his bed-time stories to the children.

WMBS IS READY TO BROADCAST

Harrisburg's newest radio station, WMBS, owned and operated by Mack's Battery Company, will be formally opened with a twenty-hour program, beginning tomorrow evening at 7.30 o'clock. About twenty local firms and organizations will be represented in the dedication.

WMBS, which will use the 360-meter length, has announced that in the interest of local listeners it will not interfere with other popular programs from the larger cities, and most of its broadcasts will be in the afternoon or early evening. A contest, with many awards to be given by the firms represented on the opening program, will be held in connection with the initial broadcast. Listeners will also be asked to inform WMBS as to the type of program they desire.

The program for the dedication tomorrow, and their sponsors, follows: 7.30 p. m., Introduction by the Harrisburg Chamber of Commerce; 8 p. m., Updegrove Five, THE PATRIOT and THE EVENING NEWS; 9 p. m., Breining Trio, Commonwealth Trust Company; 10 p. m., Pennsylvania Railroad Concert Company, State Insurance Company; 11 p. m., Johnny Whitman's Orchestra, Penn-Harris Hotel; 12 m., theater novelty. State Theater; 1 to 3 a. m., Knut Kracker Club, Mack's Battery Company.

Sunday, 11 a. m., quartet, Shaeffer's Tire Service; 12 m., Penn-Harris novelty, the Telegraph; 1 p. m., Johnnie Whitman's Orchestra; 2 p. m., Reo Flying Cloud Trio, Harrisburg Auto Company; 3 p. m., vocal program, Harrisburg Motor Club; 4 p. m., Hoover Trio, Hoover Furniture Company; 5. p. m., Fromar Trio, the Fromar Company; 6 p. m., piano recital, Stieff Piano Company; 6.30 p. m., Johnnie Whitman's Orchestra; 7.30 p. m., services from the Grace United Brethren Church, and 8.30 p. m., piano recital Stieff Piano Company.

WHBG changed hands in January 1927. While not mentioned in this article from the *Harrisburg Telegraph* (January 15, 1927, page 9), US Department of Commerce records indicate that WHBG changed call letters to WMBS and that ownership changed from John Skane to Mack's Battery Service.

W M B S RADIO STATION

360 Meters 833 Kilocycles 500 Watts Power

Studio, 206; Station Roof, State Theatre Bldg.

Owned and Operated by the

MACK'S BATTERY COMPANY

60 S. Cameron Street Harrisburg, Pa.

Sunday, March 13th

10.00 A. M.—Children's Hour, Hbg. Courier
11 00 A. M.—Dill's Inn Hour, Keystone Quartette
12.00 A. M.—State Theatre Organ Recital
1.00 P. M.—Wincroft Hour. Sacred Songs
2.00 P. M.—Harrisburg Auto Co. Hour
3.00 P. M.—Harrisburg Motor Club Soloists
4 00 P ·M.— Hoover Musical Trio
5.00 P. M.—Paul B. Tice, Lebanon, Pa. Hour
6.00 P. M.—Organ Recital, Henry & Rockey, Inc
6.30 P. M.—Studio Program
7.00 P. M.—Mrs. Chas. A. Howland, Contralto
7.30 P. M.—Grace United Brethren Services

Monday, March 14th

11.00 P. M.—Jolly Merrymakers

Tuesday, March 15th

7 00 P. M.—R. H. Mathias, Baritone
7.30 P. M.—Mary Fountain, Pianist

Wednesday, March 16th

9.00 P. M.—Studio Program, Tenor Solos

Thursday, March 17th

8 00 P. M.—Stieff Piano Artists
11.30 P. M.—State Theatre Organ Recital

Friday, March 18th

7.45 P. M.—Ohev Sholom Temple Service

Saturday, March 19th

10.00 P. M.—Hoffman's Coal Ensemble
11.00 P. M.—Square Cut Rate Artists
12.00 P. M.—Chef's Hour, Knut Kracker Enter.
1.00 A. M.—Knut Kracker Klub Ensemble

We sincerely thank you for all reports

WMBS provided program schedules for listeners who desired them. This schedule from March 13–19, 1927, shows the station's frequency (833 kHz), power level (500 watts), and location (State Theatre Building). Ironically, most of this schedule never aired due to a fire in the station's transmitter shack. (Courtesy of author's collection.)

WMBS was knocked off the air by a fire in the transmitter shelter on the roof of the State Theatre Building on Locust Street on March 14, 1927. The fire took place a mere two months after Winfield Scott "Mack" McCachren bought the station and relocated the transmitter. (© 1927 the *Patriot-News*. All rights reserved. Reprinted and used with permission of the *Patriot-News*.)

Longest Stretch of Ladder Local Firemen Ever Raised Halts City's Highest Blaze

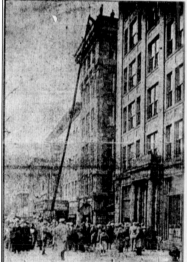
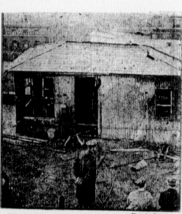

Fire Chief Tawney's men raised the greatest length of ladders in the city's history in combating the fire at radio station WMBS on the roof of the State Theater, six stories above the street, yesterday morning. The ladder, with an extension of eighty-five feet, the highest aerial ladder made, reached the top of the building with a few feet to spare, and this assisted the firemen materially in carrying up chemical tanks to battle the blaze. It is probable Harrisburg firemen never before encountered a blaze so far above the ground. The lower picture shows the damage done to the transmission room of the broadcasting station.

The *Harrisburg Telegraph* ran an article on September 9, 1927, to announce that WMBS was building a new transmitter site in Washington Heights, Lemoyne, just west of the city. Civil War buffs may know the location as Hummel's Heights. It was the site of Fort Washington and Fort Couch, built in 1863 to defend Harrisburg from a Confederate army advance into Pennsylvania. WMBS apparently had used a temporary transmitter site after the March 14 fire.

W-M-B-S to Be Back on Air September 15

May Broadcast Fight, World Series, Says Manager

IS BUILDING NEW STATION

Application has been made by the local radio broadcasting station, WMBS, which is to go on the air September 15, to hook up with the National Broadcasting Association for three important national events: the Radio Industries Banquet on the evening of September 20, the Dempsey-Tunney fight and the World Series baseball games.

This announcement was made to-day by W. S. McCachren, manager, who said that he will know definitely on Monday.

The new transmitting station at the top of Fort Washington Heights on the West Shore, which has installed new equipment at a cost of $12,000, has not been on the air under its recently assigned wave length of 234 meters since the latter part of June. The studio will remain in the State Theater Building.

A regular program will be followed beginning at 11.30 o'clock in the morning with "Popular Musicale". From noon until one o'clock will be an organ hour and from 1 until 1.30 a woman's program has been arranged in connection with the Woman's Club of Harrisburg.

At 5.50 in the afternoon baseball scores and news reports will be announced followed by the correct time at 6 o'clock. For four weeks a Merchants Air Carnival, sponsored by city merchants will be broadcast from 6 to 8 o'clock.

From 8 until 11.30 at night there will be a varied program including specialties of all kinds.

A Sunday program will last from 8.30 in the morning until 9 o'clock at night consisting of church services, music and addresses.

An increased staff of announcers has been added for the station, which will operate with 250 watts on 1280 kilocycles.

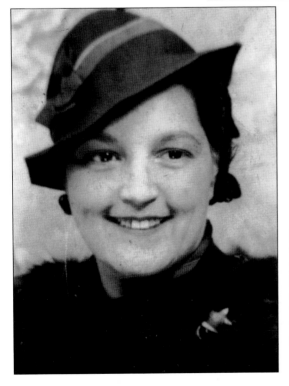

Radio offered many styles of music that were popular in the 1920s, such as vocal, jazz, orchestra, opera, and Hawaiian. Sixteen-year-old Isabelle Neumyer, contralto vocalist from Dauphin Street in Enola, regularly performed popular tunes on WMBS during 1928. She was accompanied by pianist Russ Dasher. (Neumyer was the author's grandmother.) (Courtesy of author's collection.)

Radio Engineers in New Laboratory Here to Experiment With Television

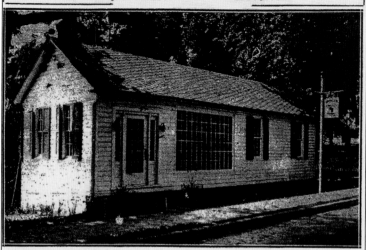

A thoroughly - equipped radio laboratory manned by engineers capable of building television sets and curing whatever ills may befall any set or speech amplifying equipment will be opened September 1 at Nineteenth and Market streets, Camp Hill, by Grim and Company.

Coincident with the opening a television apparatus will be built and placed on exhibition for the benefit of fans interested in the latest development of radio.

In connection with the laboratory a retail radio shop will be operated in which will be sold Crosley and Amrad sets which engineers of the firm pronounce the best values in the low and high-priced fields.

Will Design and Build Sets

The laboratory in addition to experiments with latest developments in the radio industry will also design, build and repair any kind of radio equipment. A complete line of accessories and parts including equipment necessary to construct television apparatus will be stocked for the benefit of both dealers and individuals.

Clair Grim Heads Engineers

Heading the engineers in charge of the laboratory is Clair Grim who was one of the city's radio pioneers, starting with his first set in 1916. The following year he was given an amateur license for 3 BBV which he operated while he mastered the technical side of radio. He is recognized as one of the foremost radio technicians in Central Pennsylvania and has been widely consulted. His brother, Russell, who has worked with him on radio problems, and his father, C. L. Grim, comprise the firm.

More than $2,000 worth of testing apparatus and other equipment has been installed in the laboratory.

While commercial radio was taking America by storm in the 1920s, experimental television was gaining momentum. A number of scientists, including Nikola Tesla and Thomas Edison, predicted that "radio vision" would some day be possible. Local amateur radio operator Clair Grim added his name to the list of would-be television developers in 1928 by opening an electronics store and laboratory in Camp Hill (*Harrisburg Telegraph*, August 30, 1928, page 13). ()

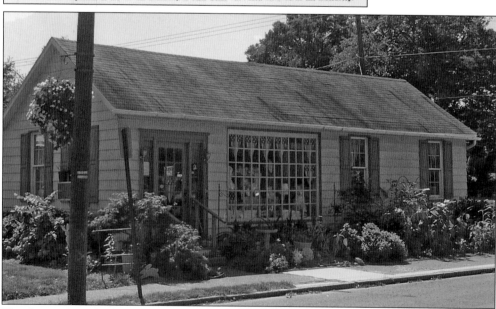

The former Grim building at Nineteenth and Market Streets in Camp Hill appears remarkably unchanged in this modern photograph. (Photograph by Tim Portzline, 2010.)

WMBS BECOMES WHP UNDER OWNERSHIP OF RADIO DEALERS

WMBS has passed into the realm of forgotten things with the change to the new call WHP, authorized by the Federal Radio Commission and used for the first time last night.

Wave length and power will remain the same, but the station hopes for favorable action on its application for 5000 watts. Ownership is in the hands of the Pennsylvania Broadcasting Company, comprised of many of the city's leading radio dealers who will continue W. S. McCachren as station manager.

Engineers have made a survey of sites in contemplation of the establishment of a 5000-watt transmitter and have discovered three suitable. All are twelve miles from the city as it is planned not to blanket reception of other stations when the increased power is permitted.

Another change announced is an alliance with the Federated Broadcasting Company which over a network of nearly a hundred stations broadcasts recordings of many leading entertainers. Negotiations are under way to convince two of the biggest broadcasting chains that they should have WHP as their local outlet.

The *Harrisburg Telegraph* frequently kept readers informed about the activities of local radio stations. This article from March 19, 1929, explains that WMBS had become WHP under new ownership of the Pennsylvania Broadcasting Company. (© 1929 the *Patriot-News*. All rights reserved. Reprinted and used with permission of the *Patriot-News*.)

WHP IS TO BE REMOVED TWELVE MILES FROM CITY

Radio Dealers Forming $200,000 Corporation to Take Over Station

Removal of Station WHP, formerly WMBS, from Washington Heights to ten or twelve miles from Harrisburg, as well as formation of a $200,000 corporation to take over the radio station, was decided at a meeting of the Radio Distributors Association of Harrisburg at the Harrisburg Club yesterday afternoon.

A committee of five headed by Charles G. Knerr, chairman, was selected to apply for a charter for the new firm. Members of the committee agreed to subscribe the necessary stock to apply for the charter while the radio distributors voted to subscribe for a large block of the stock of the new company. The rest of the stock will be placed on the market here.

Ask for 5000 Watts

Roy W. Shreiner, president of the Radio Distributors' Association, announced the decision of the group after W. S. McCachren, head of the Mack's Battery Station, explained the various steps to be taken in the new project. An application will be filed immediately with the Federal Radio Commission to secure an increase in power for the station from 500 watts to 5000 watts. The station will be moved ten or twelve miles from Harrisburg as soon as possible, it was explained, in order not to drown out other station received by listeners here.

At the present time no site for the new station has been selected. Station WHP is owned and operated by the Pennsylvania Broadcasting Company. Following incorporation, the distributors plan to elect officers from the stockholders.

Members of the committee to apply for the new charter are Charles G. Knerr, chairman; Harry E. Myers, Edward O'Brien, R. M. Peffer and Roy W. Shreiner.

Part of WHP's change of ownership to the Pennsylvania Broadcasting Company in March 1929 included a proposed power increase and a relocation of the station's transmitter. (© 1929 the *Patriot-News*. All rights reserved. Reprinted and used with permission of the *Patriot-News*.)

This advertisement for WHP radio appeared in a broadcasting magazine in May 1929. The advertisement spells out that the station was owned by the Pennsylvania Broadcasting Company at 106 S. Fourth Street, that it was formerly known as WMBS, and that it was operating on 1430 kHz with 500 watts. (Courtesy of R.J. Harris; WHP photograph collection.)

Three

THE 1930S

The 1930s kicked off radio's golden age across America. The popularity of the two major radio networks, NBC and CBS, grew tremendously during this time thanks to their comedies, dramas, and sporting events. For example, listeners tuned into *Amos and Andy* in such large numbers that theaters would not schedule movies to run while the show was on the air.

During the 1930s, WHP was taken over by the Stackpole family, owners of the *Harrisburg Telegraph* newspaper. The station was moved to the Telegraph Building at 216 Locust Street. WHP became a CBS affiliate in 1930.

WCOD changed call letters to WKBO in the early 1930s, reflecting its prior change of ownership to the Keystone Broadcasting Corporation. WKBO was the local NBC affiliate. By the end of the decade, WKBO was owned by the Mason-Dixon Radio Group, based in Lancaster, and managed by broadcasting pioneer Clair McCollough.

After sharing time with WHP on 1430 kHz for several years, WBAK ceased operating during the mid-1930s.

Ed Smith's *Junior Town* stage show started on WHP in 1938. The show originated at the Rio Theater on Walnut Street and regularly attracted around 1,000 youngsters.

The Communications Act of 1934 was passed, replacing the Federal Radio Commission with the Federal Communications Commission.

In 1938, Orson Welles broadcast his famous radio dramatization of H.G. Wells's *War of the Worlds*, causing panic about a fictitious invasion from Mars in Grover's Mill, New Jersey. WHP carried the CBS program in Harrisburg.

After many years of experiments and development, RCA presented its first public demonstration of television at the 1939 New York World's Fair.

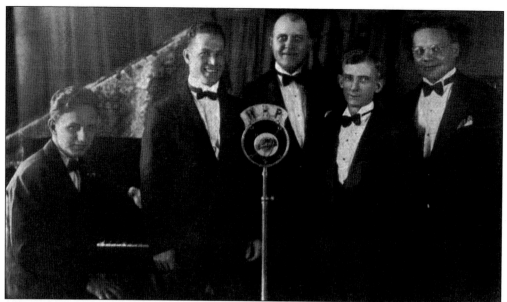

The Keystone Quartet was a popular musical act that appeared regularly on WHP in the late 1920s and early 1930s. This publicity photograph was taken in 1931. (Courtesy of author's collection.)

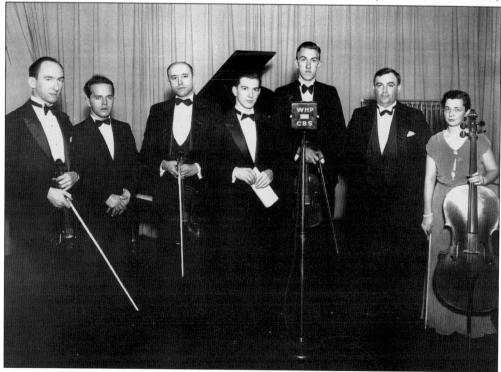

Live studio performances were a staple of early radio broadcasts. Many classical ensembles, church choirs, high school bands, and aspiring singers appeared on local stations. In this photograph from around 1930, a very young Ed K. Smith (center) was the announcer on WHP. Smith began his lengthy broadcasting and business career at WHP and went on to become one of Harrisburg's best-known radio and television entrepreneurs. (Courtesy of R.J. Harris; WHP photograph collection.)

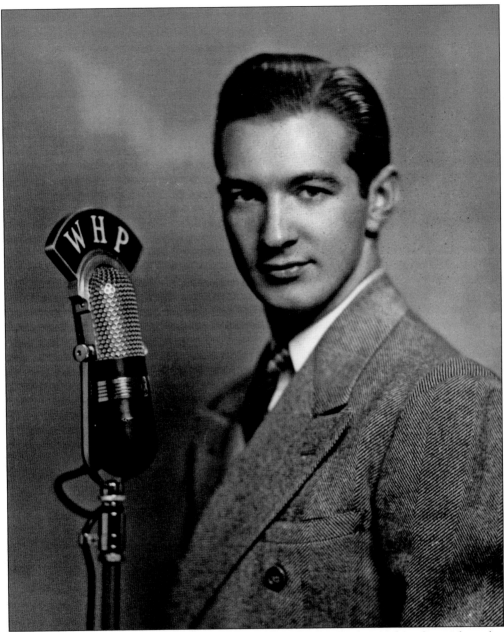

WHP announcer Edgar K. "Ed" Smith is pictured around 1930. Smith was also a featured vocalist on local shows and on the CBS network. He became WHP's production director in 1937. (Courtesy of R.J. Harris; WHP photograph collection.)

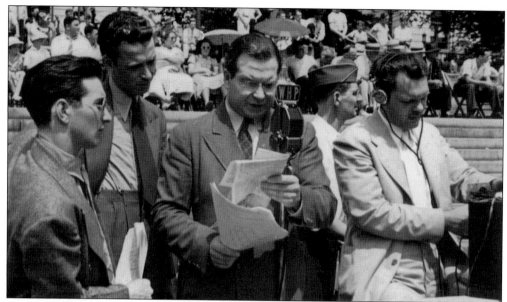

Brothers Dick and A.K. "Abe" Redmond of WHP radio (second and third from the left) provided live coverage of a parade in front of the main capitol building in Harrisburg around 1935. Abe was WHP's commercial manager, and Dick was the station program manager. The latter Redmond used his showbiz background to create highly successful dramatic programs that aired on WHP with local talent. Redmond's philosophy was that if more local performers were involved in his productions, "the more people would know and listen to WHP." (Courtesy of R.J. Harris; WHP photograph collection.)

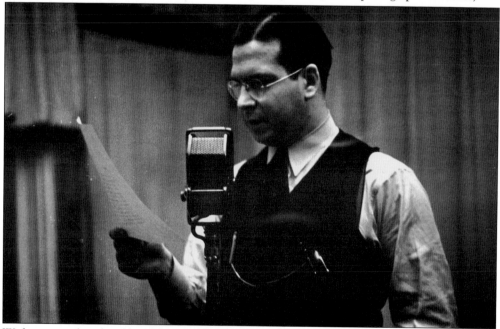

With script in hand and headphones dangling across his chest, Abe Redmond exhibits a relaxed demeanor as he handles announcing duties on WHP in the 1930s. Abe and his brother Dick were born and raised in Harrisburg in the early 1900s. Their father, Andrew Redmond, settled in Harrisburg after leaving Ireland in 1882. (Courtesy of R.J. Harris; WHP photograph collection.)

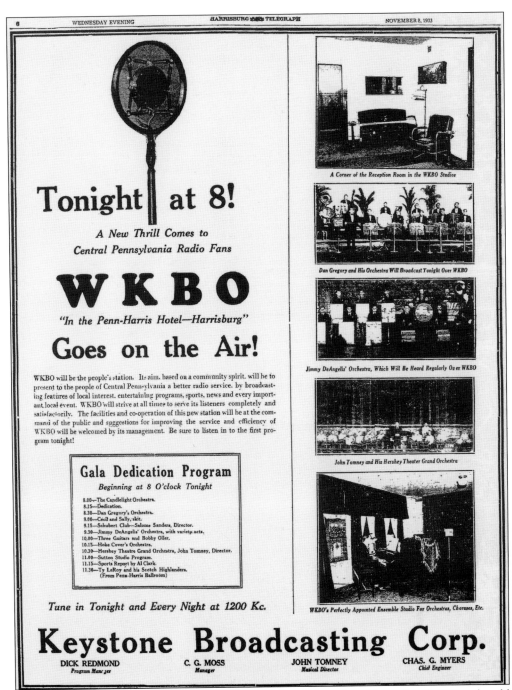

This full-page advertisement appeared in the *Harrisburg Telegraph* on November 8, 1933, to herald the start of WKBO (formerly WPRC and WCOD). The dedication broadcast featured a number of live musical acts from the Penn-Harris Hotel, including the Hershey Theatre Grand Orchestra, the Jimmy DeAngelis Orchestra, and Dan Gregory's Orchestra. (© 1933 the *Patriot-News*. All rights reserved. Reprinted and used with permission of the *Patriot-News*.)

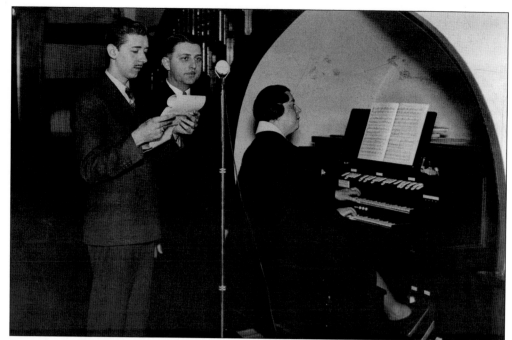

Reese Organ Melodies was a regular program on WKBO in 1937 and was presented live three times per week from Reese Funeral Home at 911 North Second Street. The program featured organist Violette Cassel (right), baritone Clark Bair (center), and announcer Will Groff (left). Initial response to the program was so strong that owner Richard J. Reese began an open house to accommodate a live audience for the Sunday afternoon broadcasts. (Courtesy of Ted Reese.)

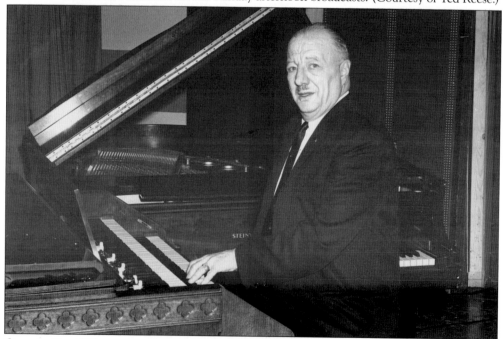

Organist David Shoop provided a variety of in-studio musical entertainment on WHP radio for many years. (Courtesy of R.J. Harris; WHP photograph collection.)

Harrisburg Telegraph

October 31, 1938, page 1

FANS STUNNED BY BROADCAST OF WAR DRAMA

Realistic Air Story Based on Famous Wells' Version

RUMORS QUELLED

The Federal Communications Commission began an investigation today of a dramatic radio broadcast which led some people to believe last night that men from Mars had attacked the United States.

Chairman Frank A. McNinch asked the Columbia Broadcasting System to furnish the Commission with an electrical transcription of the broadcast, a dramatized version of H. G. Wells' story, imaginative story, "War of the Worlds," McNinch said:

"Any broadcast that creates such general panic and fear as this one is reported to have done is, to say the least, regrettable."

In Harrisburg apparently most of the listeners to the program had heard the cautionary announcements that the program was fiction. Those who called newspapers offices were quickly reassured. Others called their pastors.

Senator Clyde L. Herring (D-Ia) said he planned to introduce in Congress a bill "controlling just such abuses as was heard over the radio last night. Radio

(Continued From Page 1)

has no more right to present programs like that than someone has in knocking on your door and screaming," he added.

City manager Paul Morton of Trenton. N. J.. near the locale of the fictional invasion. said' he would demand an investigation by the Federal communications commission "with the view of preventing recurrence of what happened."

Some apartment houses in New York were emptied hurriedly by frantic listeners to the program — and by second and third hand accounts that multiplied the impending peril.

The broadcast was an adaptation of H. G. Wells' imaginative "war of the worlds," further dramatized and enacted by Orson Welles. the 23-year-old broadway theatrical prodigy. Welles Americanized the locale and situations.

Four times during the program, CBS pointed out, the announcer stressed that the story was nothing but fiction.

Welles. who startled the theatre ocularly last season by portraying a caesar in modern dress with Fascist leanings. was overcome by the unbelievable reaction to his presentation of the Wells thriller-turned-horrifier.

All he could say after the broadcast was. "I'm sorry"

WHP Callers Ask For Rebroadcast Of Air Thriller

Numerous telephone callers today requested WHP, the Harrisburg Telegraph's radio station, to repeat last night's thrilling dramatization of the Wells' story of "War of the Worlds."

Many reported they had missed the drama, others heard only parts of it.

Some inquirers asked for a summary of the story and the public's reaction to it. WHP furnished the requested information.

On October 30, 1938, actor and director Orson Welles and his Mercury Theatre produced a radio rendition of the H.G. Wells novel *War of the Worlds*. This tale of an alien invasion was dramatized with such authenticity that it caused panic in parts of New York and New Jersey. Listeners who had not heard the entire CBS broadcast became convinced that Earth was under attack by people from Mars. The show was carried locally on WHP. (© 1938 the *Patriot-News*. All rights reserved. Reprinted and used with permission of the *Patriot-News*.)

Clair McCollough started as a newspaper carrier's helper in 1915 for the Steinman family's Lancaster Newspapers, Inc. By 1933, McCollough was the general manager of the Steinman's Mason-Dixon Radio Group, which included WGAL in Lancaster, WKBO in Harrisburg, and WORK in York. McCollough ultimately became the first manager of a television station between Philadelphia and Pittsburgh with the advent of WGAL-TV in 1949. (Courtesy of WGAL.)

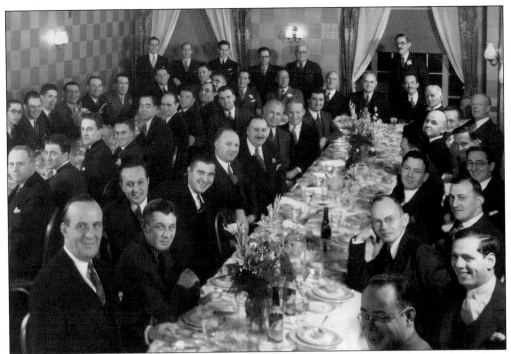

In this rare photograph from March 10, 1933, Clair McCollough (seated second row from the left, seventh from the front) was in attendance at the Hotel Edison in New York City with radio executives from around the country for a major announcement by actor and comedian Ed Wynn. Wynn, who was known for his zany Perfect Fool character on Texaco's *Fire Chief* program, was forming a new radio network called Amalgamated Broadcasting System. (Courtesy of WGAL.)

In this close-up, Ed Wynn is seen on the far right (with glasses) with Clair McCollough at the far left. Wynn launched Amalgamated Broadcasting System on September 25, 1933; however, ABS suffered from poor management, and according to historians, it rapidly fell out of favor with newspaper critics who drove away potential network sponsors. The network closed by the end of October, a mere month after it started. In spite of this failure, Wynn enjoyed a successful acting career until his death in 1966. (Courtesy of WGAL.)

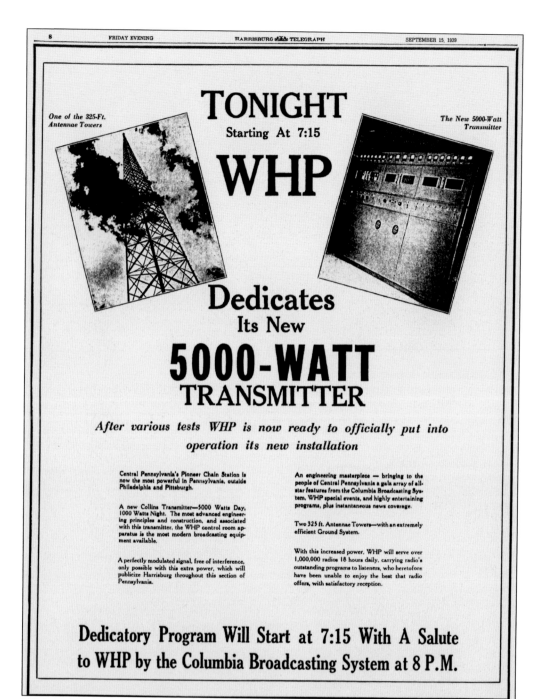

One of the 325-Ft. Antennae Towers

The New 5000-Watt Transmitter

TONIGHT
Starting At 7:15

WHP

Dedicates
Its New

5000-WATT
TRANSMITTER

After various tests WHP is now ready to officially put into operation its new installation

Central Pennsylvania's Pioneer Chain Station is now the most powerful in Pennsylvania, outside Philadelphia and Pittsburgh.

A new Collins Transmitter—5000 Watts Day, 1000 Watts Night. The most advanced engineering principles and construction, and associated with this transmitter, the WHP control room apparatus is the most modern broadcasting equipment available.

A perfectly modulated signal, free of interference, only possible with this extra power, which will publicize Harrisburg throughout this section of Pennsylvania.

An engineering masterpiece — bringing to the people of Central Pennsylvania a gala array of all-star features from the Columbia Broadcasting System, WHP special events, and highly entertaining programs, plus instantaneous news coverage.

Two 325 ft. Antennae Towers—with an extremely efficient Ground System.

With this increased power, WHP will serve over 1,000,000 radios 18 hours daily, carrying radio's outstanding programs to listeners, who heretofore have been unable to enjoy the best that radio offers, with satisfactory reception.

Dedicatory Program Will Start at 7:15 With A Salute to WHP by the Columbia Broadcasting System at 8 P.M.

WHP celebrated a major milestone with a power increase on September 15, 1939, complete with a full-blown, on-air dedication of a new transmitter. The festivities included state and local dignitaries, numerous musical acts, and a salute from Hollywood via CBS. This advertisement in the *Harrisburg Telegraph* boasted "with this increased power, WHP will serve over 1,000,000 radios 18 hours daily." (© 1939 the *Patriot-News*. All rights reserved. Reprinted and used with permission of the *Patriot-News*.)

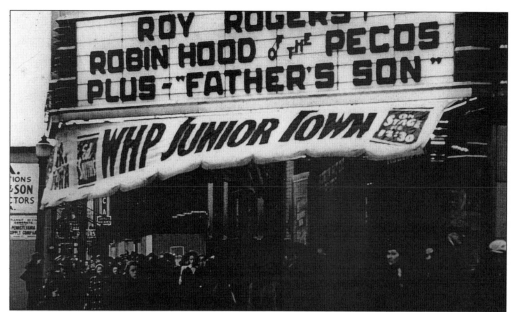

Ed K. Smith started his youth-oriented *Junior Town* variety program on WHP in 1938. It was very popular with youngsters, regularly attracting up to 1,000 attendees at the Rio Theater on Walnut Street for the live Saturday morning broadcasts. After one year on the air, the show boasted 3,500 registered "citizens," or members, including movie stars Judy Garland, Mickey Rooney, and other celebrities. The marquee pictured is from 1941. (Courtesy of R.J. Harris; WHP photograph collection.)

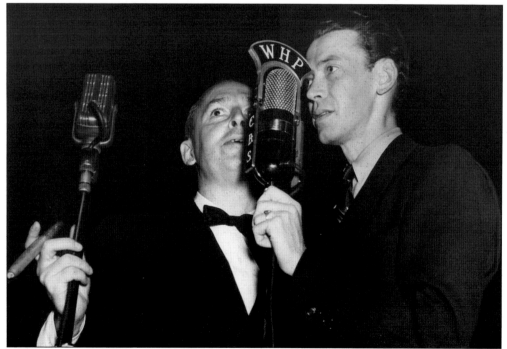

Ben Bernie and His Orchestra performed live on WHP in November 1938. Shown here with Dick Redmond, Bernie (left) was known for his trademark phrase, "Yowsa, yowsa, yowsa," and for his nickname, the "Old Maestro." (Courtesy of R.J. Harris; WHP photograph collection.)

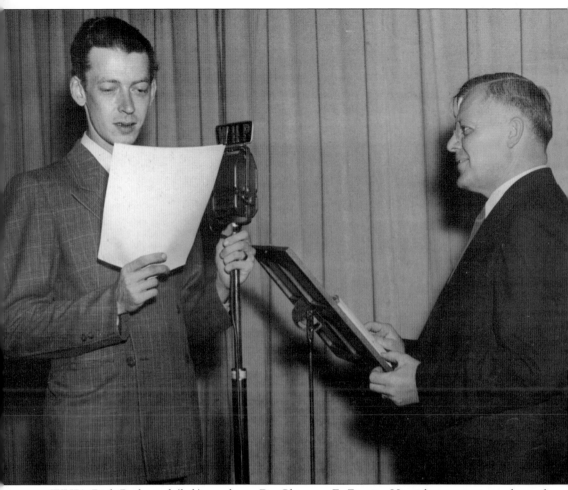

WHP's Dick Redmond (left) speaks to Dr. Clarence E. Zorgin, Harrisburg superintendent of schools. Early radio programming placed a heavy emphasis on everyday life in the community, including highlights of activities at local schools. (Courtesy of R.J. Harris.)

Four

THE 1940s

The 1940s were a time of major development in broadcasting. After decades of development and negotiating through a sea of conflicting technical standards, television finally became a reality during the 1940s.

In 1940, inventor Edwin Howard Armstrong successfully demonstrated a new, static-free method of transmission known as "frequency modulation" to the FCC. Armstrong's FM would ultimately be chosen for the audio portion of the television and would be granted a band of frequencies for radio.

Locally, WHGB (1400 kHz) began in 1945. The station was located in the basement of the Blackstone Building at Market and River Streets in Harrisburg.

WHP-FM (97.3 MHz) signed on in June 1946. The station carried a variety of musical programs and Baltimore Orioles baseball games.

WCMB (960 kHz) went on the air in 1948. The station was owned by Ed K. Smith and Edgar Shepard.

The area's first television station, WGAL (Channel 4) in Lancaster went on the air in 1949.

A nationwide frequency realignment on the AM band in 1941 moved WHP from 1430 to 1460 kHz. WKBO moved from 1200 to 1230 kHz.

While serving in Europe as a war correspondent, WHP's Dick Redmond was inspired to write the lyrics for a song that would later be recorded by Frank Sinatra.

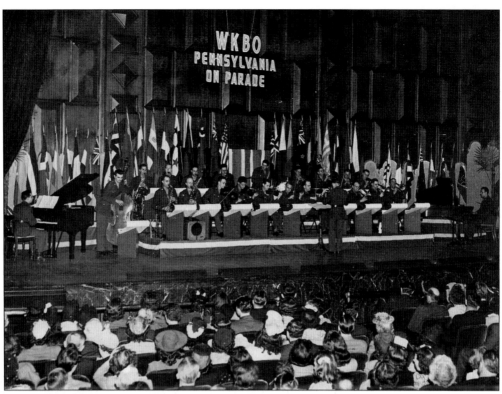

U. S. ARMY RECEPTION CENTER

Lieutenant Colonel William A. Fulmer, Post Commander

New Cumberland, Pennsylvania

presents

"PENNSYLVANIA ON PARADE"

Augmented by a Cast
of Soldier Stars

THE FORUM

Harrisburg, Pa.

Wednesday, May 5, 1943

WHP's Ed K. Smith served in the US Army during World War II as an entertainment coordinator. Sergeant Smith was responsible for producing *Pennsylvania on Parade*, a highly successful musical review that raised millions of dollars in the sale of war bonds. One such performance was held at the Forum in Harrisburg on May 5, 1943. The program was carried on Smith's former crosstown rival, WKBO. (Courtesy of R.J. Harris.)

Smith produced 25 *Pennsylvania on Parade* shows, which appeared throughout the state. In a letter from the War Finance Committee of Pennsylvania, deputy manager Sidney Weiler stated, "We of the Treasury Department consider this show one of the outstanding events in assisting us to raise money to furnish equipment for our fighting men." Smith also produced overseas shows and managed entertainment at a stateside army hospital. (Courtesy of R.J. Harris.)

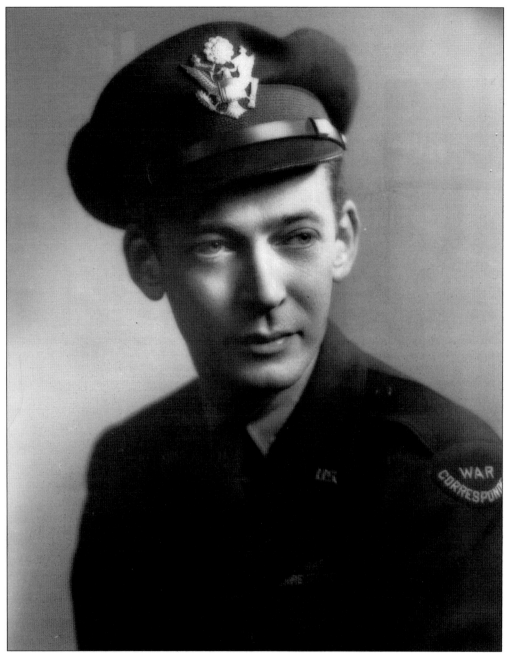

When WHP's Dick Redmond went to Europe to serve as a correspondent during World War II, he couldn't have known that he would come home with a song concept that would be sung by a major recording star several years later, but on June 14, 1948, "Just for Now" was released by Frank Sinatra. It went on to be used in the sound track for *Whiplash*, released by the Warner Bros. later that year and starring Dane Clark and Alexis Smith. "Just for Now" received massive airplay in Harrisburg on the day it was released. (Courtesy of R.J. Harris; WHP photograph collection.)

STATION IDENTIF. Time 1	TIME Begin 2	TIME End 3	ANNOUNCER 4	TITLE 5	SPONSOR 6	COMM ANN 7	ORIGIN 8	RENDITION Type 9	RENDITION Time 10	PROG TYPE 11	OPER. SIGN. 12
10:36 P.M. 10:36		11:01.35	W. M.	Dedication of F.M Sta			CBS			√	

When WHP-FM began broadcasting on June 6, 1946, transmitter operator C.J. Lentz made one simple entry into the station's program log: "Dedication of FM station." With that, WHP-FM became the first FM station in Harrisburg at 10:36 p.m. Among the station's first announcers were John Price, Joe Harper, Ulna Goodall, Lee Cronican, Cliff Hoffman, Harry Hinkley, Bill Erdossy, Ed Gundaker, and Ron Drake. The station has changed call letters and owners several times during its history. It became WRVV (the River) in March 1992. (Courtesy of author's collection.)

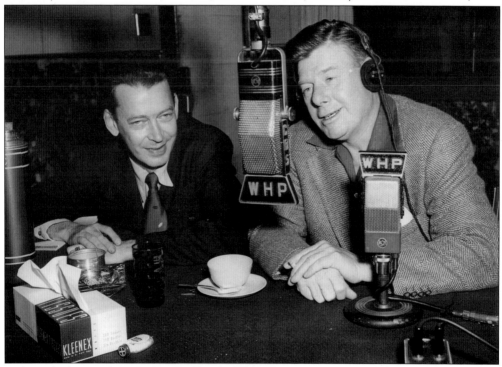

Radio and television host Arthur Godfrey (right) made an appearance in WHP's studios with Dick Redmond (left) in the late 1940s. Godfrey was the host of several highly popular shows on CBS: *Arthur Godfrey Time* and *Arthur Godfrey's Talent Scouts*. Godfrey had a neighborly, down-to-earth manner that made him well known; however, off the air, he could be considered controlling and spiteful at times. Godfrey's kindly image suffered in 1953 when fans heard him fire popular singer Julius LaRosa on the air. (Courtesy of R.J. Harris; WHP photograph collection.)

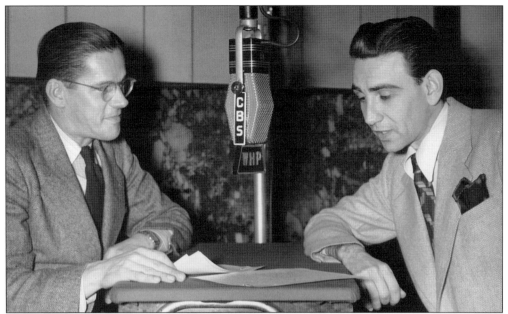

Ed Gundaker (left) and Ron Drake share WHP's microphone around 1947. Originally from New York, Drake came to WHP as a staff announcer in 1946. He applied his skills to television on WHP-TV in the 1950s with shows such as *TV Teen Time*. By 1960, he would take the reigns of WHP radio's morning show and lead the station into huge ratings that lasted for several decades. (Courtesy of R.J. Harris; WHP photograph collection.)

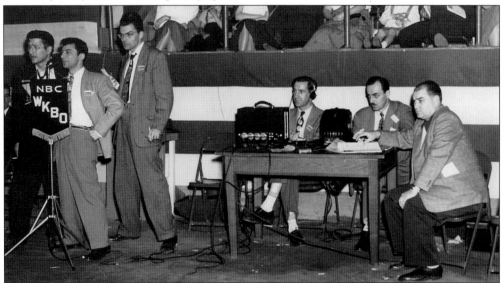

Two of Harrisburg's legendary broadcasters, Pete Wambach and Mike Ross, are shown in this remarkable photograph from around 1948. After leaving WKBO, Wambach (far left) had a long career as an air personality at WCMB and hosting the statewide radio program *This is Pennsylvania*. After briefly pursuing a stage career, Mike Ross (second from left) returned to Harrisburg to be a reporter and news anchor for WTPA (later WHTM) for 50 years. Don Wear, future general manager of WTPA TV, is the gentleman seated in the middle at the table. (Courtesy of WGAL photograph collection.)

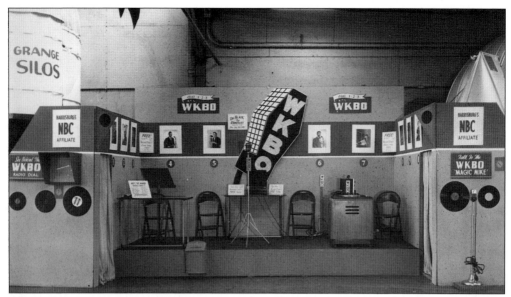

Where there is a crowd, there is a potential viewer or listener. Pennsylvania is a major agricultural state, and the Pennsylvania Farm Show in Harrisburg attracts a vast number of attendees every year. Radio and television stations throughout the area once saw this event as a valuable way to gain visibility with the Central Pennsylvania audience. This elaborate display was used by WKBO in the late 1940s. (Courtesy of WGAL photograph collection.)

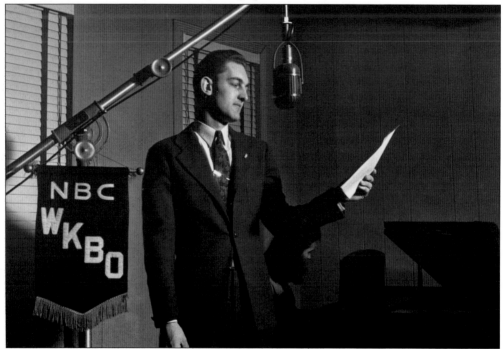

WKBO was an NBC affiliate in Harrisburg for many years, a fact that it proudly promoted in many publicity photographs, such as this one from the late 1940s. WKBO was owned by the Mason-Dixon Radio Group from the late 1930s until 1971. It was co-owned with WGAL in Lancaster and WORK in York, along with stations in Hazelton, Easton, and Delaware. (Courtesy of Fred Leuschner.)

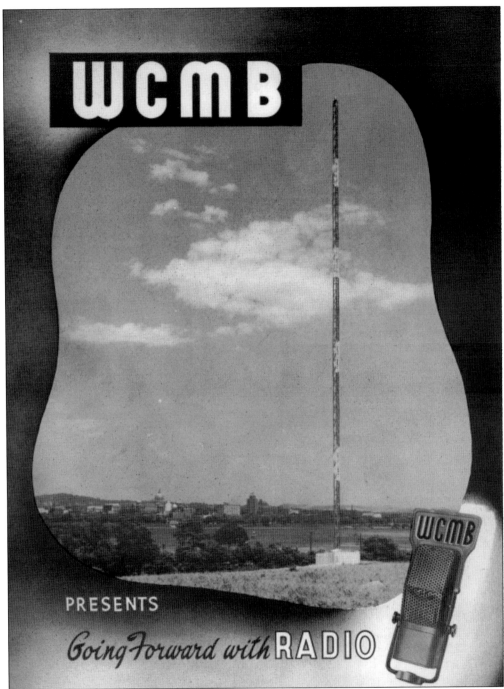

Edgar "Ed" K. Smith returned to Harrisburg and started an advertising agency when his Army career ended in 1946. Smith and business partner Edgar T. Shepard formed the Rossmoyne Corporation in January 1947 for the purpose of starting a radio station. By February 1948, WCMB was a reality. The transmitter site, located in Wormleysburg, had a beautiful view of the city from across the Susquehanna River. (Courtesy of author's collection.)

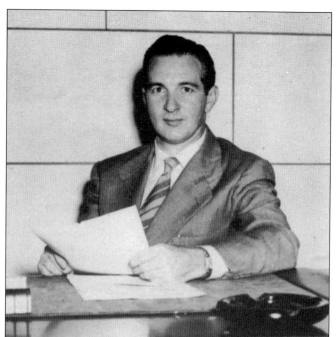

Throughout his career, Ed Smith was regarded as a strong leader and a fair man. His colleagues often spoke very highly of him. Smith was highly involved in professional and civic organizations, such as the Pennsylvania Association of Broadcasters, the West Shore Chamber of Commerce, Goodwill Industries of Central Pennsylvania, the American Red Cross, and the Pennsylvania Chamber of Commerce. When Smith passed away in 2001 at age 87, he was remembered by fellow broadcaster Pete Wambach as "one of the most generous persons I've ever known." (Courtesy of author's collection.)

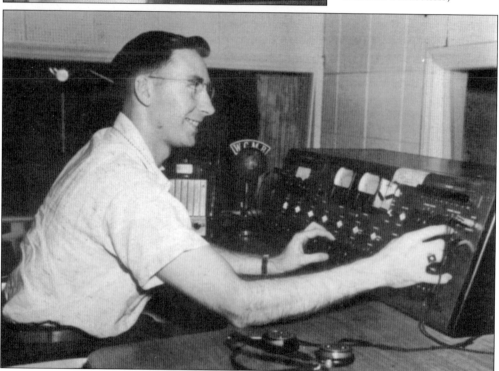

When WCMB went on the air in 1948, the studios were located on the second floor of the Lemoyne Theatre building at 322 Market Street in Lemoyne. Dick Kerlin, seated at the station's audio console, was part of WCMB's original technical staff. Kerlin also had the distinction of being one of the original staff members at WTPA in 1953 (later WHTM) where he stayed for many years. (Courtesy of author's collection.)

Many of WCMB's early programs were live productions. At the time, quiz shows, musical programs, and celebrity interviews were a mainstay of radio stations throughout the country. WCMB's main studio was built to accommodate a live audience of roughly 60 people. (Courtesy of author's collection.)

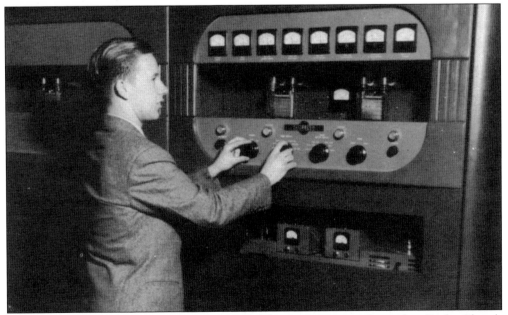

WCMB was on 960 kHz when it began in 1948. The transmitter was located on Poplar Church Road in Wormleysburg, not far from the studios. In coming years, the entire WCMB radio operation would be consolidated into an enlarged building at this site. The building was a landmark until its demolition in May 2010. Earl Hocker, a station engineer, is shown here adjusting WCMB's Collins transmitter. (Courtesy of author's collection.)

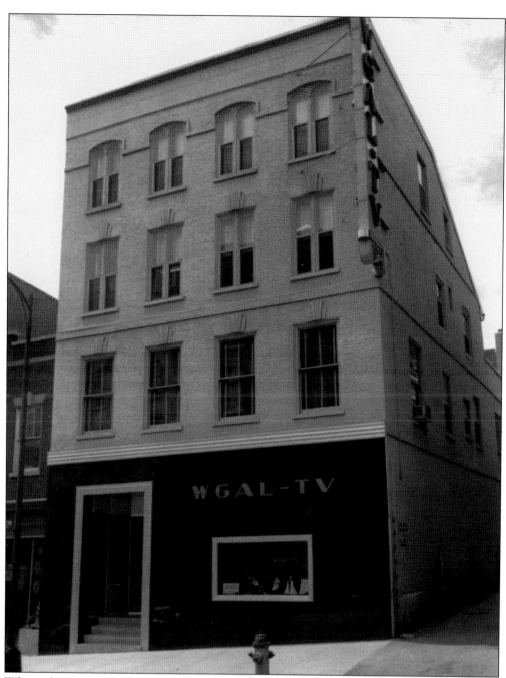

When television arrived in Central Pennsylvania, WGAL in Lancaster was the first to broadcast. The Steinman-owned station began life on Channel 4 on March 18, 1949. It was only the 37th commercial TV station in the country. WGAL's studios were located at 24 South Queen Street in Lancaster with the transmitter nearby at 8 West King Street. The first local personalities to appear on WGAL were Nelson Sears and Dave Brandt. The station was affiliated with NBC, CBS, ABC, and DuMont. (Courtesy of WGAL.)

F. C. C. Form No. 380

UNITED STATES OF AMERICA
FEDERAL COMMUNICATIONS COMMISSION

File No. .BPCT-138.....
Call Letters ..WGAL-TV.

TELEVISION BROADCAST STATION CONSTRUCTION PERMIT

Subject to the provisions of the Communications Act of 1934, subsequent Acts, and treaties, and all regulations heretofore or hereafter made thereunder, and further subject to the conditions set forth in this permit, authority is hereby granted to......W.G.A.L. INC...
to construct a television transmitter station located and described as follows:
1. Location of transmitter: State.Pennsylvania... County..Lancaster......
City or Town... Lancaster......................
Street and number..8.West King Street..................
North Latitude: Degrees....40.......... Minutes.....02....... Seconds...15....
West Longitude: Degrees....76.......... Minutes.....18....... Seconds....23....
2. Location of main studio: State..Pennsylvania.. County....Lancaster....
City or Town.....Lancaster.................. This permit is granted subject to the
Street and number....8.West King Street....... following: (a)that Section 3.652 of
3. Description of transmitting equipment: lations is waived on the condition
Vis. RCA TT-500A rated power 0.5 kw. the Commission's Rules and Regu-
Operating power output 0.515 kw. that the permittee install a frequen-
Aur. RCA TT-500A rated power 0.25 kw. cy monitor of the accuracy of .001%
Operating power output 0.25 kw. or better when approved monitors be-
4. Description of antenna system: come available.; (b) contingent on
RCA TF-3 B, 3 bay superturnstile power gain filing Form 301 for changes in WGAL
of 4.0. antenna.
Horizontal field pattern: Omnidirectional.
Antenna supporting structure 170' self-supporting tower on a 100' building.
Overall height above ground: 318'.
Tower to be painted and lighted in accordance with attached specifications.
5. Operating assignment:
(a) Frequency.......66-72.....Megacycles. (Channel No. ...4......).
(b) Effective radiated power: Visual..1.0...kw., Aural.....0.88....kw.
(c) Antenna height above average terrain..............260.........feet.
(d) Hours of operation - Unlimited.
6. Date of required commencement of construction......March 8, 1948......
7. Date of required completion of construction........September 8, 1948...
8. Equipment and program tests may be conducted pursuant to Sections 3.616 and 3.617 of the Commission's rules, following the completion of construction in exact accord with this permit. The authority herein contained to conduct tests shall not be construed as a television broadcast station license, but only to make tests incident and necessary to proper construction of the station, and the Commission reserves the right to cancel or modify such authority.

9. This permit shall be automatically forfeited if the station is not ready for operation within the time specified or within such further time as the Commission may allow unless completion of the station is prevented by causes not under the control of the permittee.

Dated this......8th........ day of....January......, 19 48

By direction of the FEDERAL COMMUNICATIONS COMMISSION,

(S E A L)
jc

..
Secretary

This is arguably one of the most significant documents in the history of broadcasting in Central Pennsylvania. It is the construction permit granted by the FCC on January 8, 1948, allowing WGAL, Inc., to begin the creation of the first television station between Philadelphia and Pittsburgh. It is the legal go-ahead that is required before a broadcasting station can be built. Without it, WGAL would never have existed. The image above was scanned from the original document. (Courtesy of WGAL.)

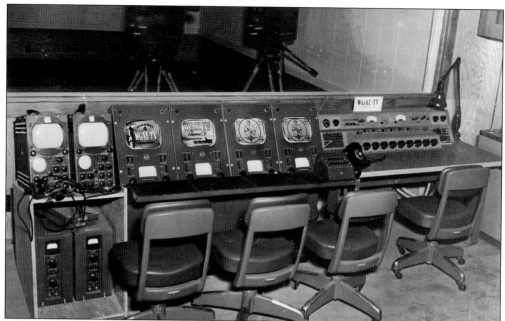

This control room is where WGAL's local programs originated from 1949 to 1956. Two studio cameras can be seen through the window. In the foreground, several of the TV monitors display station logos that read, "WGAL Channel 4." (Courtesy of WGAL.)

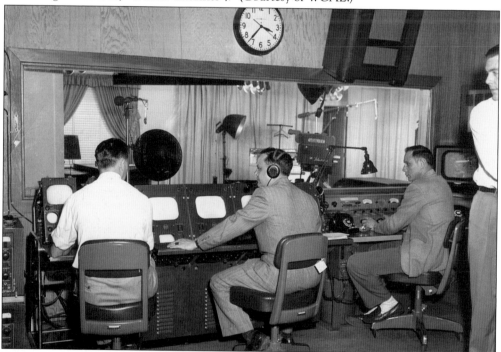

During a typical program, the control room was staffed by a director, an engineer, an audio operator, a light operator, and an announcer. Since videotape was still a few years away at this point, local programs were aired live. If someone made a mistake, there was no going back to fix it. (Courtesy of WGAL.)

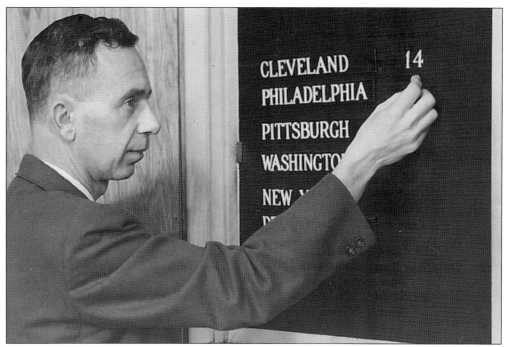

WGAL's first anchor, David Brandt, is pictured around 1950. Brandt, a native of Lancaster County, retired in 1982 after 44 years with WGAL. He began at age 18 as a sports announcer for WGAL radio. (Courtesy of WGAL.)

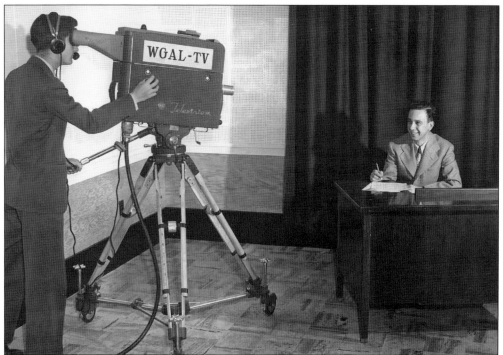

WGAL's Nelson Sears is shown at the camera, and David Brandt appears at the news desk. (Courtesy of WGAL.)

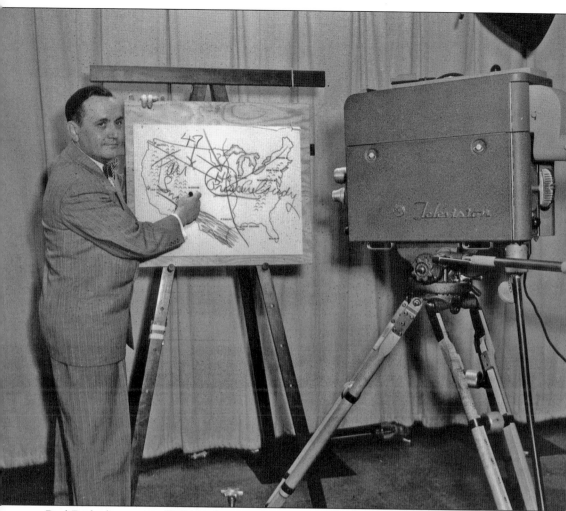

Paul Rodenhauser was WGAL's first weatherman and program manager in 1949. Rodenhauser also played Santa on the *Santa Claus Show* from 1954 until he left the station in 1966. (Courtesy of WGAL.)

Five

THE 1950S

The 1950s were marked by a number of major events in broadcasting in the greater Harrisburg-Lancaster-Lebanon-York market.

WHP (AM) moved from 1460 to 580 kHz on May 21, 1951. As part of the switch, WCMB took over WHP's old frequency, shifting from 960 to 1460 kHz and raising power from one to five kilowatts.

WSBA television (Channel 43) in York started on December 21, 1952. Louis J. Appell was the president and station owner of Susquehanna Broadcasting Company. WSBA is known today as WPMT.

WHP-TV officially became the first television station within Harrisburg city limits on April 15, 1953, at 8 p.m. The moment was highlighted when Harrisburg mayor Claude Robins pressed the switch to join CBS for the *Arthur Godfrey Show*. WHP-TV was originally on Channel 55. The studios were located in the *Harrisburg Telegraph* building on Locust Street in Harrisburg. The station's on-air testing began on April 1, 1953.

WTPA (TV) became the second television station in Harrisburg proper on July 6, 1953 at 9 a.m. Mayor Robins was on hand for the event. The first program was *Ding Dong School*. WTPA started as an NBC affiliate on Channel 71. To date, the station is still at its original Hoffman Street location.

Lebanon's WLBR (Channel 15) became the next television station in the area on October 12, 1953. The station temporarily went dark in 1954, returning to the air again under new ownership in May 1957.

By September 1954, WCMB-TV (Channel 27) was Harrisburg's next television station within city limits after WHP and WTPA. However, the station was a DuMont affiliate, which did not bode well for the station's future. DuMont failed not long after WCMB signed on, leaving the station with insufficient programming. The station went dark in 1957.

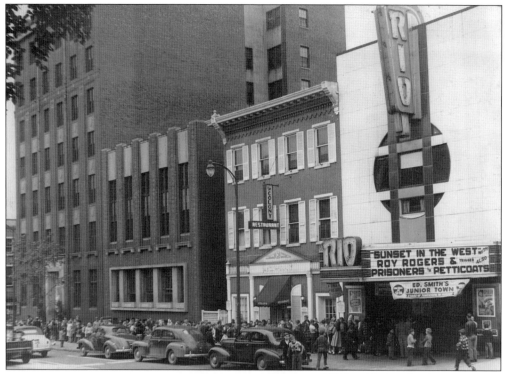

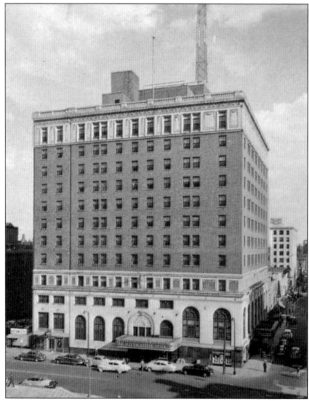

Ed Smith's popular *Junior Town* radio show continued into the early 1950s at the Rio Theater, located at 323 Walnut Street in Harrisburg. The site was originally the Majestic Theatre, dating to the early 1900s. The building was razed in the mid-1950s and is now occupied by Strawberry Square. (Courtesy of R.J. Harris; WHP photograph collection.)

The Penn-Harris Hotel on Walnut Street was once a major attraction in downtown Harrisburg. This 400-room facility, adjacent to the capitol building, also served as WKBO's rooftop tower site for many years until the hotel was demolished in 1973. The location is now occupied by Strawberry Square. WKBO's studios were located nearby at 31 North Second Street. (Courtesy of Dave Ratcliffe.)

Date May 21, 1951

8:10 PM — Tower Lites DK.

STATION IDENTIF. Time	TIME		ANNOUNCER	TITLE	SPONSOR	COMM ANN	ORIGIN	RENDITION		PROG TYPE	OPER. SIGN.
	Begin	End						Type	Time		
1	2	3	4	5	6	7	8	9	10	11	12
	8:00:07	8:27:14	L.C.	Star Playhouse	Bromo-Seltzer	X	CBS			D	
	8:27:16		" + DR	Instructions to Listeners to retune			LS			S	
				their receivers to 580 KC							
		8:29:16	— Final sign-off of WHP on 1460 KC								

WHP AM changed frequencies several times over its first quarter-century before finally settling on its current 580 kHz location. This program log records that WHP made the switch on May 21, 1951, with the "final sign-off of WHP on 1460 KC." WHP had been operating its old frequency for 10 years. (WCMB moved to 1460 soon after WHP's relocation.) (Courtesy of author's collection.)

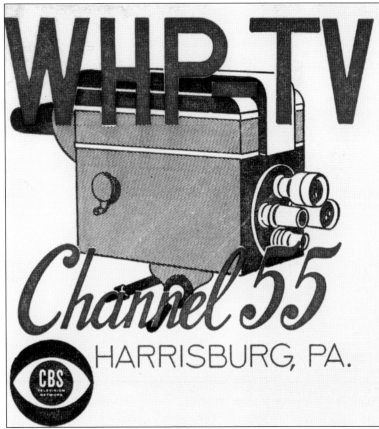

When WHP-TV began broadcasting on April 15, 1953, it was on Channel 55. The station relocated to Channel 21 in 1961. (Courtesy of author's collection.)

In this photograph from 1953, a crew began to erect WHP-TV's tower on Blue Mountain, north of Harrisburg. Adjacent to the tower was a brick building that housed WHP's transmitter and monitoring equipment. (Courtesy of R.J. Harris; WHP photograph collection.)

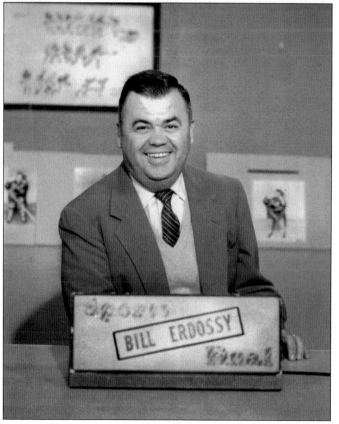

Broadcasting and sports have had a close association since the birth of radio. Some historians believe that the airing of live sports did more to sell radios and televisions in the early days than any other single type of programming. Bill Erdossy was WHP-TV's sports anchor in the 1950s. (Courtesy of Bill Kauffman.)

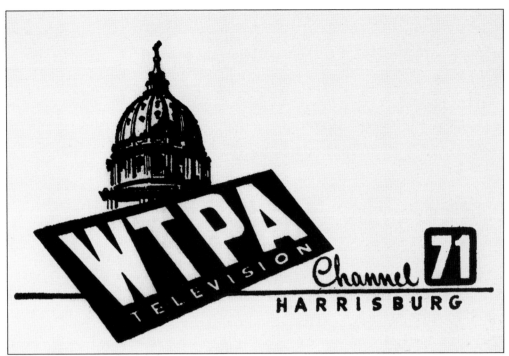

WTPA was originally assigned to Channel 71 when it began broadcasting in 1953. It moved to Channel 27 only four years later to improve reception. (Courtesy of WHTM.)

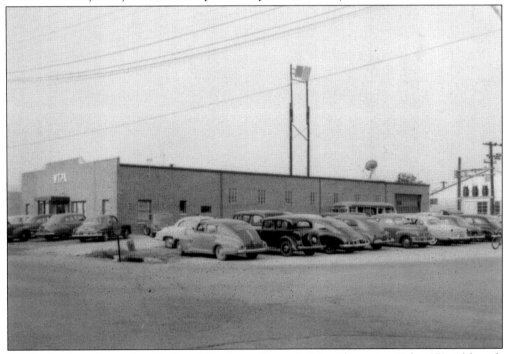

WTPA has been located at Sixth and Hoffman Streets in Harrisburg since July 1953. Although the building has changed considerably since then, present-day WHTM still occupies the same building. (Courtesy of WHTM.)

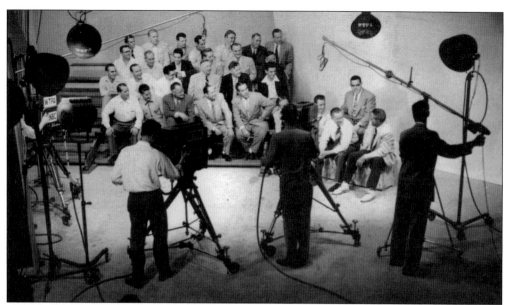

Roy Nassau hosted WTPA's show *Beat the Bench* in the 1950s. It aired on Friday nights from 9:30 p.m. to 10 p.m. It was an audience participation quiz show about sports. Participants in the bleachers came from local organizations like the Rotary Club and Kiwanis Club. The game centered on having local sports personalities answer questions on current sports topics. If the guest was wrong, fans in the bleachers were rewarded by moving up to the bench if they could provide a correct answer. (Courtesy of Fred Leuschner.)

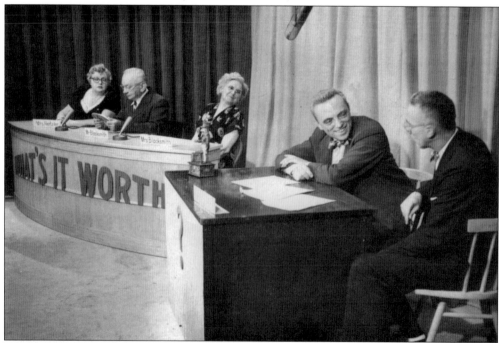

WTPA's *What's It Worth* show was along the lines of the modern *Antiques Roadshow*. Dave Bennett (fourth from left) was the host. Area residents could have valuables appraised by local antiques dealers and other experts. The show aired on Wednesday nights at 10:30 p.m. (Courtesy of Fred Leuschner.)

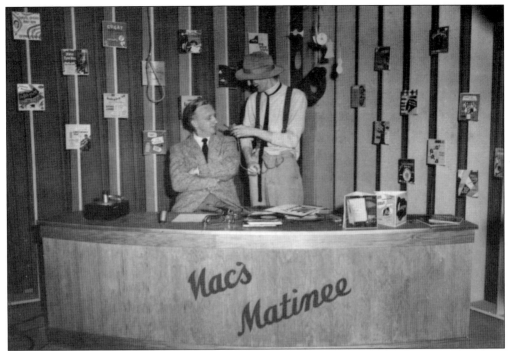

Mac's Matinee aired weekdays on WTPA from 12:30 to 1:30 p.m. It was a deejay show with Mac McCauley (left) as the host and namesake. As music was playing, the crew created unusual lighting and camera effects to provide visual entertainment. Between songs, McCauley interacted in comedy skits with Ed Baekey (right) as Sylvan Schlumper. (Courtesy of Fred Leuschner.)

WTPA program director Don Wear hosted *Home Edition*, a very early version of the nightly news in the 1950s. He presented local, national, and international news daily from 6:30 to 6:45 p.m. Prior to coming to WTPA, Wear had worked at WKBO in the 1940s. (Courtesy of Fred Leuschner.)

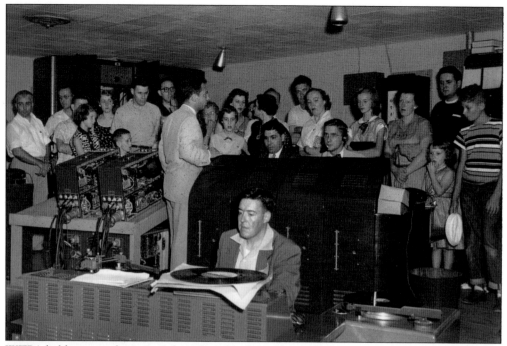

WTPA held an open house in July 1953 to let the public see how a television station operates. In this photograph, Mike Ross (standing, center) conducts a tour of the control room. (Courtesy of Betty Bryan and Fred Leuschner.)

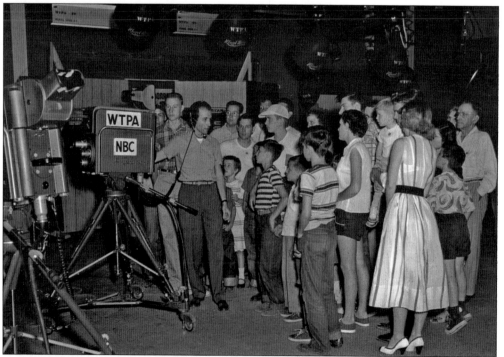

Al Wolfe explains the job of a camera operator to a tour group during WTPA's open house in July 1953. (Courtesy of Betty Bryan and Fred Leuschner.)

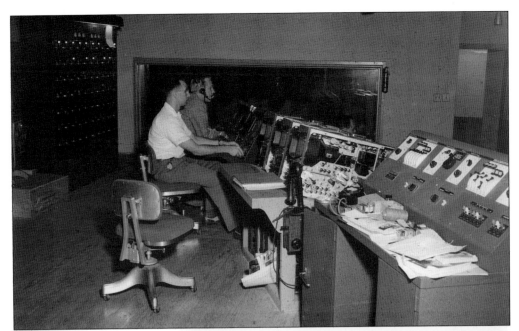

A television production begins in the studio, but it takes the people in the control room to put it on the air. Engineer Dick Kerlin (foreground) and production manager Mac McCauley were two of the people responsible for making sure that everything looked right for WTPA's viewers. During a normal production, there were five or six people in the control room. (Courtesy of Betty Bryan and Fred Leuschner.)

Multitalented Mike Ross sings during A Year for You, a program commemorating WTPA's first anniversary on July 6, 1954. (Courtesy of Betty Bryan and Fred Leuschner.)

Al Wolfe (left) and Ed Baekey (right) were WTPA's in-house comedy team. They were also part of the station's production crew and had responsibilities behind the scenes. This photograph was from the station's first anniversary program on July 6, 1954. (Courtesy of Betty Bryan and Fred Leuschner.)

Skyline Towers was a WTPA music show with the Al Morrison Trio (left), Ed Baekey (far right), and Anita Lawrence (middle). It aired on Tuesday nights at 10 p.m. with Baekey and Lawrence singing popular songs. Baekey doubled as the host. (Courtesy of Betty Bryan and Fred Leuschner.)

Mike Ross is a Harrisburg television institution. Born Michael Rosenberger of Lakewood, Ohio, Ross started his local broadcasting career as a staff announcer at WKBO in 1948. His baritone singing voice led to a role in a national tour of the musical *Guys and Dolls* in the early 1950s. Ross joined WTPA (later known as WHTM) shortly after the station signed on in 1953. (Courtesy of WHTM.)

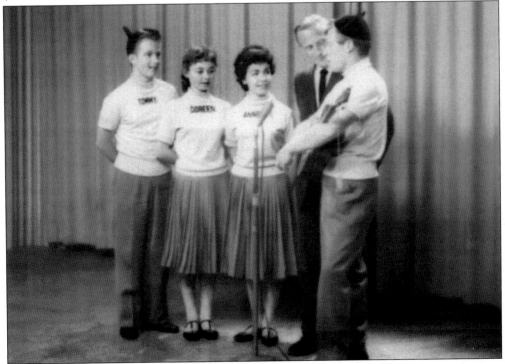

Mac McCauley (fourth from left) interviewed Mouseketeers Tommy Cole, Doreen Tracey, Annette Funicello, and Jimmie Dodd of *The Mickey Mouse Club* on WTPA. *The Mickey Mouse Club* ran from 1955 to 1959 on ABC. (Courtesy of Betty Bryan.)

DF - Don Fisher
EB - Ed Baehey
AB - Al Bethel
MM - Mac McCauley

ABBREVIATIONS:
Col. 9 N—N.B.C. Network; L—Local Studio; F—Film Chain; R—Remote
Col. 10 & 11 F—Film; S—Slide; K—Kinescope; R—Record Or E. T.; T—Tape.
Col. 14 A—Agricultural; D—Drama; E—Educational; M—Music; N—News;
 V—Variety.

1 Station Ident. Time	2 Start	3 End	4 Program Title	5 Sponsor
8:59:52	8:59:50	9:00:00	Sign On	
	9:10:10	9:59:35	Morning Marquee	
	9:59:40	9:59:57		Look Whats Cooking
9:59:59	10:00:02	10:29:29	Ding Dong School	General Mills
	10:29:35	10:29:49		Break The Bank
10:29:54	10:30:04	10:59:30	Glamour Girl	
	10:59:36	10:59:54		First Edition
10:59:56	11:00:05	11:14:30	Hawkins Falls	
	11:14:34	11:14:52		Ladies Choice
11:14:54	11:15:04	11:29:31	The Bennetts	
	11:29:24	11:29:54		Harrisburg Hostess
11:29:56	11:30:04	11:44:31	Mrs USA	
	11:44:33	11:44:52		First Person
11:44:53	11:45:04	11:59:32	Mrs USA	
	11:59:35	11:59:50		The Goldbergs
11:59:52	11:59:59	12:14:34	Daily Devotions	
	12:14:37	12:14:53		Theatre 71
12:14:55	12:15:02	12:29:58	First Edition	
	12:29:59	12:30:19		Cartoon Time
12:30:21	12:30:26	12:59:41	Mac's Matinee	
	12:59:43	12:59:59		Private Secretary
1:00:01	1:00:05	2:00:10	Theatre 71	
	2:00:20	2:00:35		Atom Squad
2:00:37	2:00:43	2:29:36	Harrisburg Hostess	
	2:29:37	2:29:52		Home Edition
2:29:53	2:30:04	2:59:35	Look Whats Cooking	
	2:59:37	2:59:55		Ladies Choice
2:59:56	3:00:00	3:14:27	Break The Bank	

ON — Chas W. Baker 8:30 A OFF

—Sport

| 8 Sust. | 9 Orig. | Mechanical Reproduction | | | 13 Announcer | 14 Type | 15 Remarks |
		10 Aur.	11 Vis.	12 Time Announced As			
L	L		S		DF		
L	L	F	FS	9:00:30 / 9:59:32	DF	D	
L	L		S		DF		
	N					E	
L	L		S		DF		
L	N					V	
L	L		S		DF		
L	N					D	
L	L		S		DF		
L	N					D	
L	L		S		DF		
L	N					NE	
L	L		S		DF		
L	N					N-E	
	L		S		EB		
L	L				EB	R	
L	L		S		EB		
L	L				EB-AB	N	
L	L		S		EB		
L	L	R		12:31:24 / 12:59:00	MM	M	
L	L		S		DF		
L	L	F	FS	1:00:30 / 2:00:00	DF	D	
L	L		S		EB		
L	L				EB	E	
L	L		S		EB		
L	L				EB	E	
L	L		S		EB		
L	N				EB	V	

This is a portion of WTPA's program log from July 24, 1953. The log is a list of programs as they took place on WTPA. The engineer who made the notations was Charles Baker. This log was created mere weeks after the station went on the air. The programs that ran on this day include kid's show *Ding Dong School*, deejay show *Mac's Matinee* with Mac McCauley, and *Look What's Cooking* with Pauline Cooper. (Courtesy of Tom Walker.)

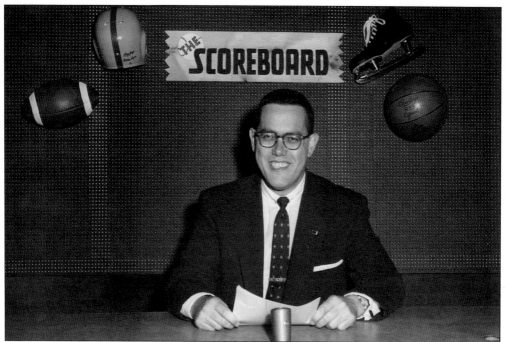

Roy Nassau was a WTPA news anchor and sportscaster. He hosted *The Scoreboard* show in 1956. Nassau also worked in public relations for Gov. George Leader from 1955 to 1958, announced in Philadelphia at WFIL and WPVI from 1958 to 1972, and was the voice of the Mummers New Year's Day parade for many years. He returned to Harrisburg in 1972 as press secretary for Gov. Milton Shapp and several state departments. (Courtesy of Fred Leuschner.)

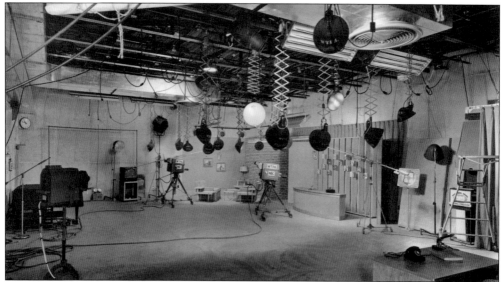

This is how WTPA's studio looked in the 1950s. Backdrops from various shows can be seen along the far wall. The production crew was responsible for operating the cameras, positioning the microphone booms, adjusting lighting, and building the sets. Many of the crew appeared in front of the cameras as well. According to production manager Mac McCauley, "We did everything!" (Courtesy of Betty Bryan and Fred Leuschner.)

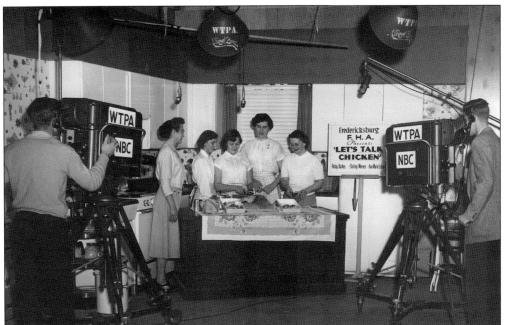

Look What's Cooking with Pauline Cooper was a regular feature on WTPA. Robin Nevitt (left) and Don Fisher can be seen operating the cameras. (Courtesy of Betty Bryan and Fred Leuschner.)

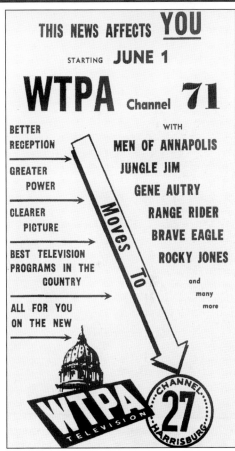

THIS NEWS AFFECTS **YOU**

STARTING **JUNE 1**

WTPA Channel **71**

BETTER RECEPTION →	WITH
	MEN OF ANNAPOLIS
GREATER POWER →	**JUNGLE JIM**
	GENE AUTRY
CLEARER PICTURE →	**RANGE RIDER**
	BRAVE EAGLE
BEST TELEVISION PROGRAMS IN THE COUNTRY →	**ROCKY JONES**
	and many more
ALL FOR YOU ON THE NEW →	

Moves To

WTPA TELEVISION — CHANNEL **27** HARRISBURG

This advertisement ran in the *Patriot-News* on May 31, 1957. WTPA moved from its original Channel 71 location to Channel 27 on the following day, June 1, 1957. Moving to a lower channel meant the WTPA's signal was easier to receive for many people. This change was made possible when WCMB-TV folded. (© 1957 the *Patriot-News*. All rights reserved. Reprinted and used with permission of the *Patriot-News*.)

This was WTPA-TV's logo as it appeared in the late 1950s. WTPA carried programming from NBC, ABC, and DuMont. (Courtesy of Fred Leuschner.)

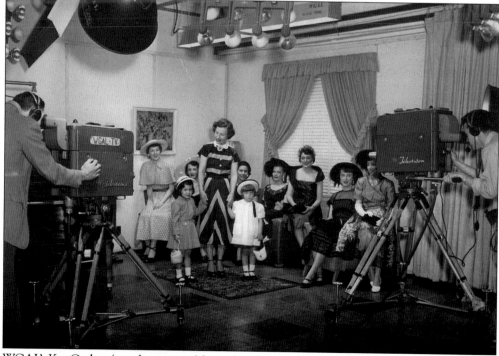

WGAL's Kay Cuskey (standing, center) hosted *Today with Kay* in the early 1950s. She interviewed guests, played the piano, and sang on the program. (Courtesy of WGAL.)

WGAL presented an open house on Christmas Day in 1956 during the dedication of its new building. General manager Clair McCollough can be seen at the far right. (Courtesy of WGAL.)

After operating in downtown Lancaster for several years, WGAL chose this location on Columbia Avenue for its new studios and offices in the mid-1950s. (Courtesy of WGAL.)

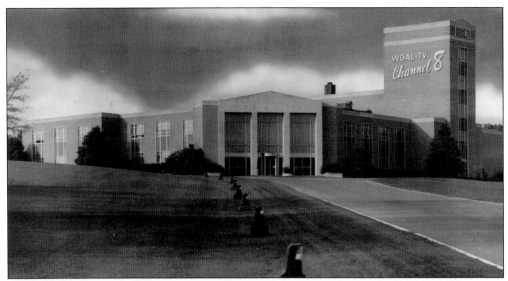

Above is WGAL's new building on Columbia Avenue in Lancaster as it appeared in 1956. It looks remarkably unchanged today. (Courtesy of WGAL.)

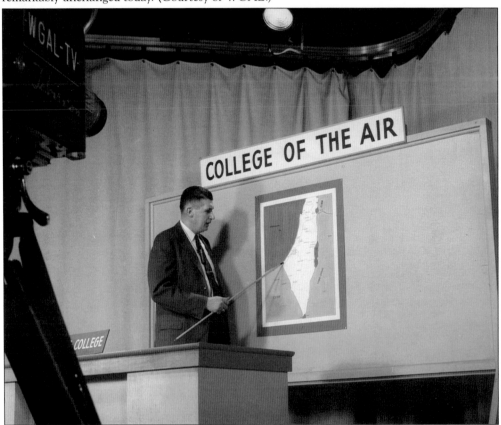

College of the Air was a program presented by Franklin & Marshall College on WGAL in the 1950s and 1960s. Educators in the fields of science, sociology, and the humanities were invited to discuss a variety of topics on the program. (Courtesy of WGAL.)

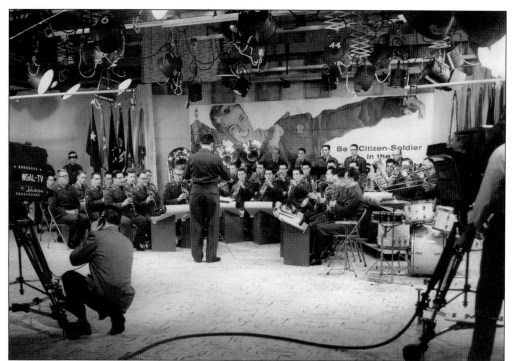

WGAL's new studio building on Columbia Avenue in Lancaster went into operation on Christmas Day 1956 with great fanfare, including a performance by a military band. (Courtesy of WGAL.)

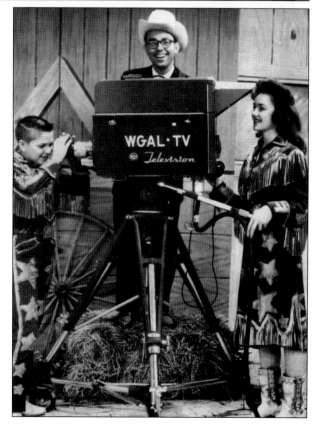

Country singer Buck Benson and the Collins Kids appeared on WGAL in the 1950s. Benson was known for performing on radio, television, and stage with his Country Neighbors band. (Courtesy of Bill Kauffman.)

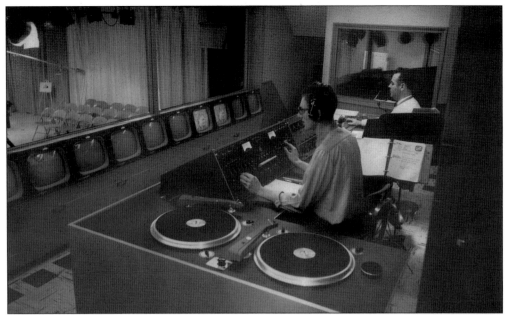

WGAL built two spacious studios and control rooms in the new building on Columbia Avenue in Lancaster in 1956. The control rooms were staffed by an audio operator (foreground) and a director. An announcer sat in the both at the far end of the room (top right). The row of monitors across the front of the room allowed the director to select the proper cameras during a television show. (Courtesy of WGAL.)

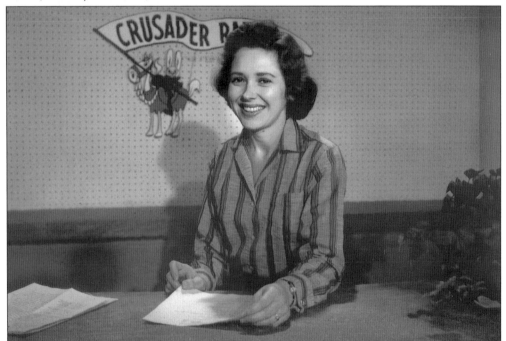

Pioneering broadcaster Marijane Landis was known for creating (or cocreating) and hosting children's shows like *Crusader Rabbit, Percy Platypus and His Friends,* and *Sunshine Corners* during her 41-year career with WGAL. (Courtesy of WGAL.)

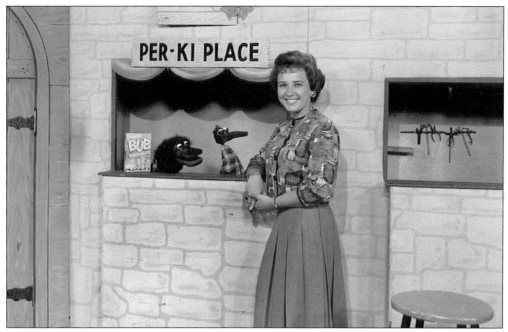

Marijane Landis, along with puppeteer Jim Freed, entertained kids for many years on WGAL. Although Landis stopped hosting children's shows in the 1970s, she continued with WGAL as a personnel director until her retirement in 1993. (Courtesy of WGAL.)

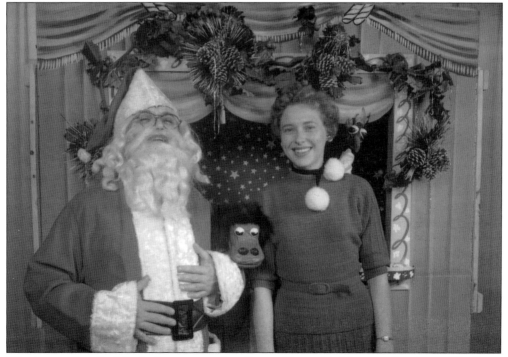

Weather anchor Paul Rodenhauser posed as Santa Claus with Marijane Landis on *The Santa Claus Show* on WGAL from 1954 into the early 1960s. Landis was inducted into the Pennsylvania Association of Broadcasters Hall of Fame in 1998. (Courtesy of WGAL.)

Most members of production crews in the early days of television did just about everything from hosting shows to operating cameras. That's how it was when John MacAlarney arrived at WGAL in 1957. During his 23-year tenure at the station, MacAlarney was best known as a news anchor. MacAlarney left WGAL in 1980 and went to FM Christian station WDAC in Lancaster to work as a newscaster until his retirement. (Courtesy of WGAL.)

These two articles were part of a series by the *Patriot-News* about Harrisburg's new television station, WCMB, on September 8, 1954. The first article describes the station's programming, which included DuMont shows like *Life Is Worth Living* with Bishop Sheen, *Captain Video*, and *The Goldbergs*. The second article predicts excellent reception for WCMB-TV's viewers. (© 1953 the *Patriot-News*. All rights reserved. Reprinted and used with permission of the *Patriot-News*.)

Available Regularly
Station to Present New TV Shows in Harrisburg

Many of television's dramatic, sports and specity features that seldom have been seen in this area will be available regularly for the first time because of WCMB's primary affiliation with the Du-Mont Network.

Such programs as Bishop Sheen's "Life Is Worth Living," professional football and others have reached the Harrisburg audience only sporadically and mostly es kineoscope recordings on a delayed broadcast basis.

However, Ed Smith, general manager of WCMB, said that local viewers will be able to get "mirror clear" reception now for such favorite events as DuMont's Monday night fights from St Nicholas Arena, the Goldbergs, Plainclothes Man, Rocky King, Detective; Capt. Video, Chance of a Lifetime, The Stranger, Night Editor and others.

Smith cited other programs that will be televised this fall through WCMB-TV including Studio 57 Frederic March Theatre. They Stand Accused, Greatest Football of the Week and Down You Go.

Viewers to Get Super Power On Channel 27

When WCMB-TV starts its telecasting schedule, it will be the first time super power has been used in Harrisburg television.

The new station will take to the air with a giant 12 kw. transmitter that will send a super power-

ful signal of nearly 240.000 watts, with its antenna electronically "tilted" so the peak strength is beamed into the city.

Ed Smith, station manager, explained that ultra high frequency originally was established as a low power form of television transmission. However, he added, UHF has been so improved during the last 18 months that the former 1 kw transmitters have become obsolete.

Station engineers pointed out that with the new transmitter, the high power may have to be applied gradually over several days.

And with the antenna directed toward Harrisburg viewers should be able to pick up the Channel 27 signal without an outdoor antenna.

Smith said Harrisburg's new super power station is one of the most powerful in the country and is supplemented by what he said engineers term a "beautiful channel" which should boost power to fringe areas.

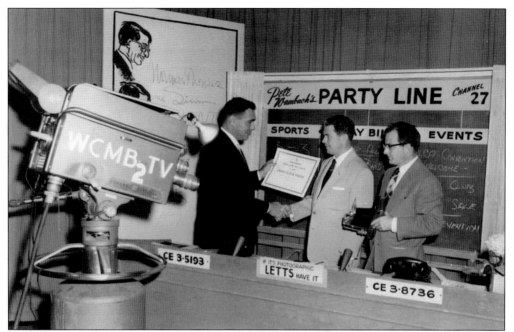

Representatives of Letts Camera made an appearance on the set of Pete Wambach's show on WCMB-TV in the mid-1950s. WCMB's television studios were located on the 200 block of North Court Street in Harrisburg near the capitol. Pictured from left to right are unidentified, W. Dixon Morrow, and J. Robert Morrow. (Courtesy of Brock Kerchner.)

This is a modern photograph of WCMB-TV's transmitter building on Blue Mountain in East Pennsboro Township. It is one of the only remaining pieces of the short-lived station, which was on the air from September 8, 1954, to April 9, 1957. The building is now owned by a tower rental company and houses cellular and other communications equipment. (Courtesy of author's collection.)

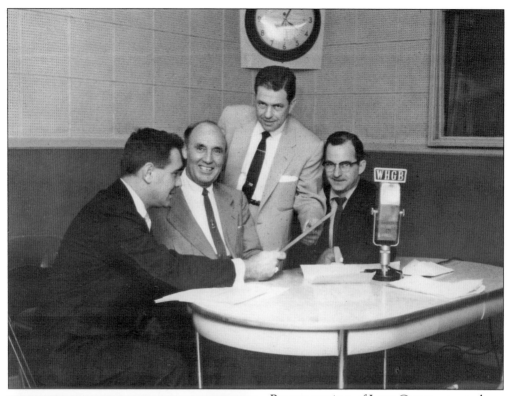

Representatives of Letts Camera stopped by to speak to WHGB's Red McCarthy during his show around 1955. WHGB was located in the basement of the former Blackstone Building at River and Market Streets in Harrisburg. Pictured from left to right are unidentified, McCarthy, W. Dixon Morrow, and J. Robert Morrow. (Courtesy of Brock Kerchner.)

Once known as the Blackstone Building, 112 Market Street was the home of WHGB (later WFEC) from its beginning in 1945 until the early 1980s when the studios and offices were relocated to the 900 block of Market Street. The station's self-supporting tower once stood on the roof of the building. (Courtesy of author's collection.)

Baritone-voiced Dr. Olin Harris Sr. was a true trailblazer in Harrisburg broadcasting. In 1957, Harris launched gospel music radio program *Echoes of Glory* on WKBO (1230), a legacy carried on for many years by Toby Young on WCMB 1460 (now WTKT). (Courtesy of the Harris Family Library.)

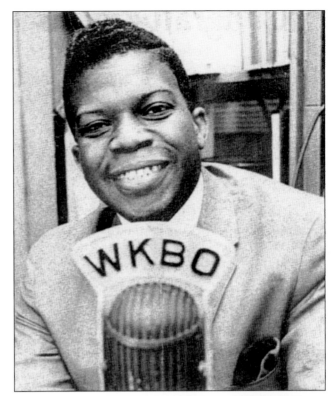

George "Toby" Young (left) posed with singer James Brown in this photograph at the Zembo Temple in 1959. Young is a longtime Harrisburg broadcaster, entrepreneur, gospel singer, and community activist. Originally from Alabama, Young moved to Harrisburg in 1946 and graduated from William Penn High School in 1951. Young served in the US Army in the mid- to late-1950s, and he was part-owner of Soulville Records in the 1960s. (Courtesy of George Young.)

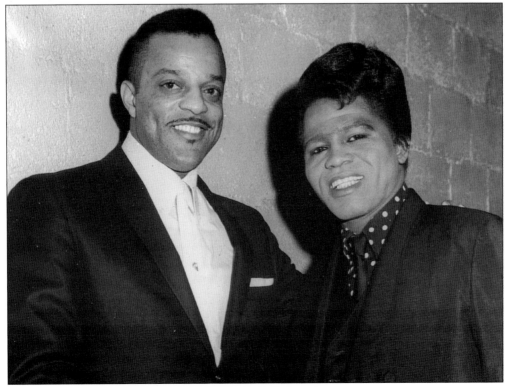

⚡WCMB⚡
★ PERSONALITIES

ED GONZALEZ . . . our wake-up habit in Harrisburg, is Head Clockwatcher. More than 6,000 households have registered memberships in his Clockwatchers Society.

There's a smile and a song waiting for you daily on this popular WCMB program.

WEEKDAYS from 6:00 a. m. until 9:30 a. m.

PETE WAMBACH . . . is the area's foremost musical authority and commentator on all topics. You hear all the great and near great guesting on Pete's popular show . . . the most listened-to show of its kind in Harrisburg according to Pulse.

Mondays thru Fridays from 4 p. m. until 5 p. m.

This page came from a WCMB promotional booklet that featured station personalities, including Ed Gonzales and Pete Wambach. Gonzales was the morning show host on WCMB. Wambach came from WKBO and had a long career with WCMB. He also hosted the statewide radio program *This is Pennsylvania*. Both men also appeared on WCMB-TV from 1954 to 1957. (Courtesy of author's collection.)

Six

THE 1960S

The 1960s marked several major milestones in Harrisburg.

WTPA-FM (104.1) started in 1962. It was the sister station of WTPA-TV, Channel 27. Like many FM stations of the time, WTPA featured light instrumental music for a number of years. The station became FM104 in 1980, and then switched to WINK 104 (WNNK) in 1985.

Under the leadership of the late Rev. John Tate, the Market Square Presbyterian Church put WMSP (94.9) on the air in 1962. The listener-supported station featured classical music and religious programming. WMSP originally occupied several classrooms in the church building on Market Square until the studios were relocated next to the church at 24 S. Second Street. The station's antenna was moved from the church's steeple to WSFM's tower in Wormleysburg in 1973, and the power was increased from 1,700 to 50,000 watts. WMSP was constantly hampered by a meager budget and the decision was made to allow commercials in 1985. The church sold the station in 1988.

WCMB-FM began broadcasting in 1965. The station carried light instrumental music for a number of years. The station became Rock 99 in 1978 with R.J. Harris as the program director. The station went through a number of formats since then, including Sunny 99, Mix 99.3, and KOOL 99.3. It is currently KISS FM.

Ron Drake began his WHP morning show in 1960. Drake was a huge figure in Harrisburg broadcasting until his retirement in the early 1980s. His morning show held the number one position for years.

In July 1961, WHP-TV moved from Channel 55 to Channel 21. The lower channel made reception easier. (Cable television eventually made reception problems a thing of the past for most viewers.)

WITF-TV began in 1964, launching public television in Harrisburg.

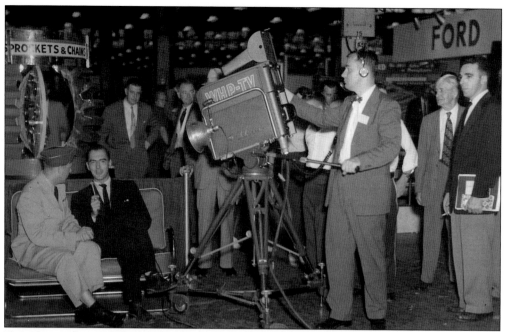

Harrisburg native Joe Harper's local career spanned 14 years at WHP before moving on to stations in Oklahoma City, Columbus, and Philadelphia. Harper (second from left) was the coanchor of the *Ten O'Clock Action News* at WPIX in New York City from 1973 until his retirement in 1976. He passed away in Maine at age 61 in 1983. (Courtesy of Bill Kauffman.)

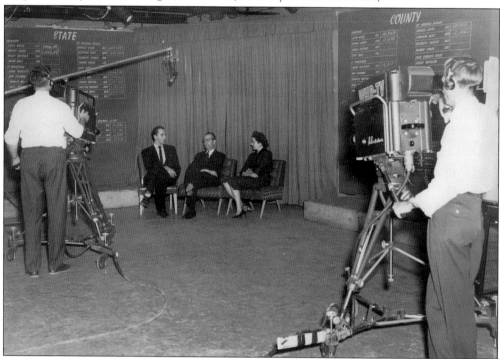

Newsman Joe Harper (seated, left) is seen here conducting an interview in WHP-TV's studio around 1960. (Courtesy of Bill Kauffman.)

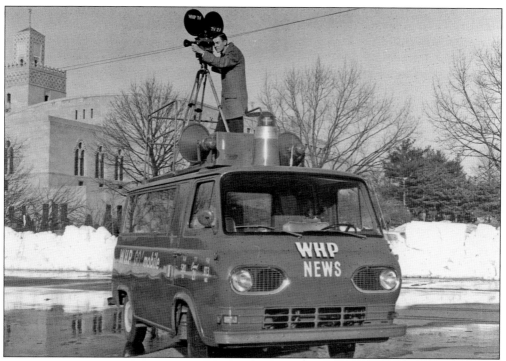

WHP's "Go Mobile" van was used to cover news events in Harrisburg. This was before the days of live TV trucks. News was captured on film and had to be processed before it appeared on the air. This photograph was taken in front of the one of the city's landmarks, the Zembo Temple. (Courtesy of Bill Kauffman.)

Jim English was a weatherman on WHP in the 1960s. This photograph is from 1966. For a time, English was known as "the Atlantic Weatherman" because he dressed in the uniform of an Atlantic Gas Station attendant. (Courtesy of R.J. Harris.)

Newscaster Sandy Fouts started with WHP in 1959. Fouts, whose real name was Myron Foutz, was with Armed Forces Radio Network during the Korean War. He left WHP in 1964 to serve in the US Army. Fouts was killed in 1965 in a helicopter crash over South Vietnam. (Courtesy of R.J. Harris.)

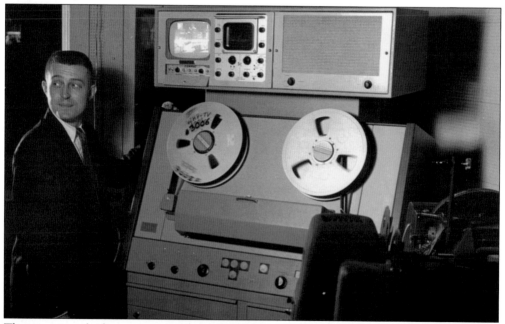

The invention of videotape was a major breakthrough in the history of television. In this photograph from the mid-1960s, WHP program director Brod Seymour poses beside an Ampex VR1100 quad videotape machine. Seymour, a native of Brooklyn, New York, had a long history of television experience before coming to WHP in late 1959. (Courtesy of Bill Kauffman.)

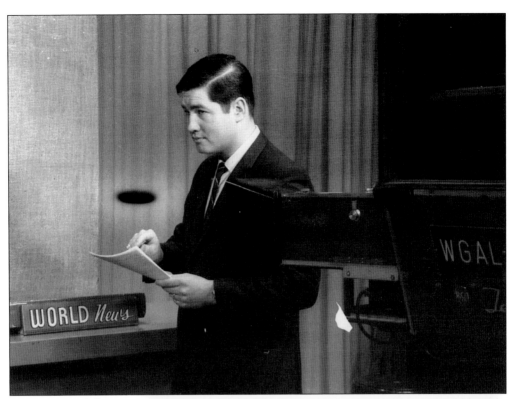

WGAL's Wendall Woodbury hosted *Dance Party* in the late 1960s. The show ran from 1961 to about 1970. Woodbury was also a news anchor, feature reporter, and host of *Wendall's World* before leaving the station in 1992.

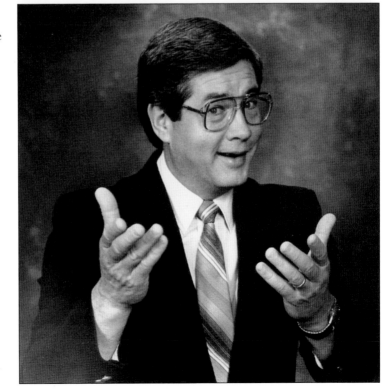

Wendall Woodbury, a Maine native, operated his own video production company in the 1990s, producing documentaries, commercials, and corporate videos. Woodbury passed away in October 2010. (Courtesy of WGAL.)

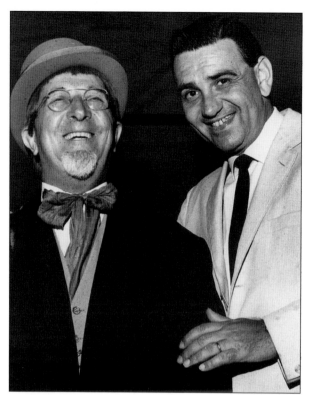

One of the gags in Ron Drake's (right) bag of tricks on WHP 580 was Professor Schnitzle. Schnitzle was a Pennsylvania Dutch character created by Theodore Richenbach (left) that appeared on Drake's morning show. Richenbach passed away in 1969. (Courtesy of R.J. Harris.)

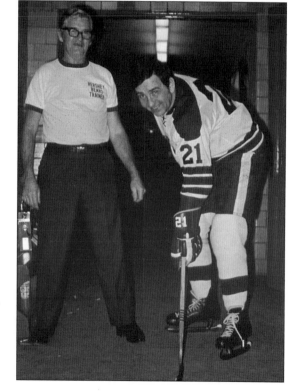

The Hershey Bears AHL hockey team has been a sports fixture in the Hershey-Harrisburg area since the 1930s. In this photograph from the 1960s, WHP's Ron Drake suits up as Bears trainer Scotty Bowman gives Drake some pointers. (Courtesy of R.J. Harris.)

Olin Harris continued to push back color barriers in broadcasting by becoming a full-time announcer and news anchor on the WHP stations in 1966. In his later years, Harris was the host of *Gospel Cavalcade Live* on the Touch 95.3. Harris was also an ordained minister, noted soloist, and recipient of awards from the NAACP and the Pennsylvania Association of Broadcasters. He passed away in 2009. (Courtesy of Rodger McGrinney.)

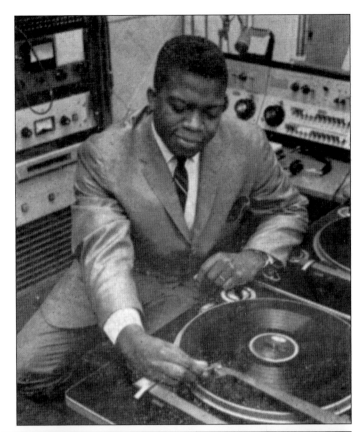

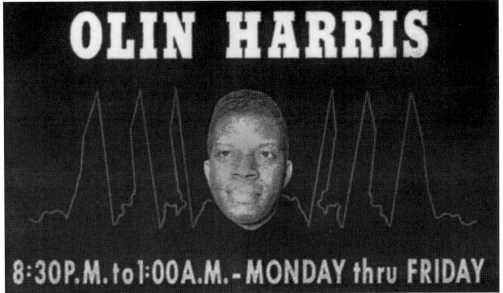

Olin Harris was on WHP radio from the mid-1960s to the early 1970s. Later in life, Harris also appeared on WWII 720 (Shiremanstown, Pennsylvania), WGCB-TV Channel 49 (Red Lion, Pennsylvania) and WDAC 94.5 (Lancaster, Pennsylvania). (Courtesy of the Harris Family Library.)

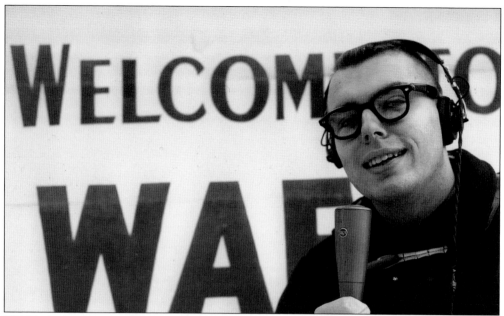

WHP's Andy Musser grew up in Lemoyne on Harrisburg's West Shore. He graduated from West Shore School District and studied speech and dramatic arts at Syracuse University. Musser developed his broadcasting skills in Harrisburg in the mid- to late-1950s with a part-time job at WHGB. By 1962, Musser was anchoring sports and weather on WHP-TV and announcing on WHP radio. (Courtesy of Andy Musser.)

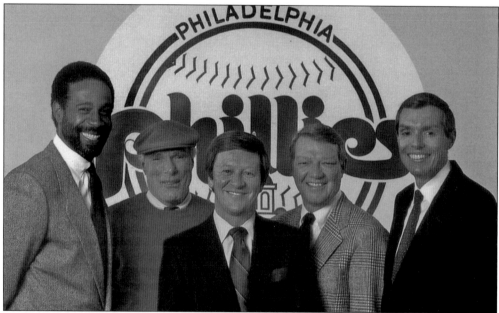

Andy Musser is best known for his long career as an announcer for the Philadelphia Phillies from 1976 until his retirement in 2001. Shown here, from left to right, is the Phillies radio team in 1988: Garry Maddox, Richie Ashburn, Chris Wheeler, Harry Kalas, and Musser. Musser also announced Eagles football games on the WCAU radio starting in 1965. (© 1988 Philadelphia Phillies, used by permission.)

The late Lt. Gen. Albert H. "Bill" Stackpole was part of the Stackpole family that once owned the *Harrisburg Telegraph* newspaper, Stackpole Books, Telegraph Press, and WHP, Inc. (Courtesy of R.J. Harris.)

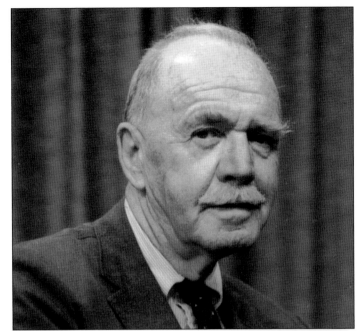

WHP program director Brod Seymour (left) had the opportunity to meet stars of many CBS television shows during the 1960s, including Bob Denver, who played Gilligan on *Gilligan's Island.* (Courtesy of R.J. Harris.)

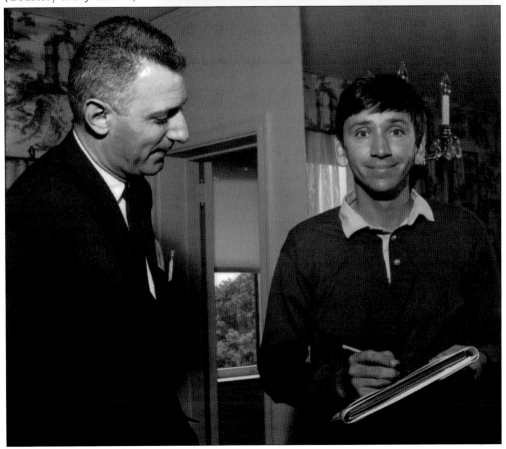

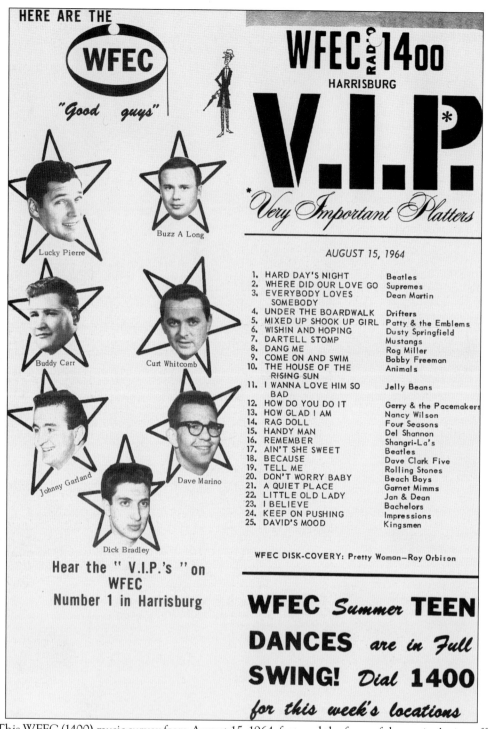

HERE ARE THE

WFEC

"Good guys"

Lucky Pierre

Buzz A Long

Buddy Carr

Curt Whitcomb

Johnny Garland

Dave Marino

Dick Bradley

Hear the " V.I.P.'s " on
WFEC
Number 1 in Harrisburg

WFEC RADIO **1400**

HARRISBURG

V.I.P.*

Very Important Platters

AUGUST 15, 1964

1.	HARD DAY'S NIGHT	Beatles
2.	WHERE DID OUR LOVE GO	Supremes
3.	EVERYBODY LOVES SOMEBODY	Dean Martin
4.	UNDER THE BOARDWALK	Drifters
5.	MIXED UP SHOOK UP GIRL	Patty & the Emblems
6.	WISHIN AND HOPING	Dusty Springfield
7.	DARTELL STOMP	Mustangs
8.	DANG ME	Rog Miller
9.	COME ON AND SWIM	Bobby Freeman
10.	THE HOUSE OF THE RISING SUN	Animals
11.	I WANNA LOVE HIM SO BAD	Jelly Beans
12.	HOW DO YOU DO IT	Gerry & the Pacemakers
13.	HOW GLAD I AM	Nancy Wilson
14.	RAG DOLL	Four Seasons
15.	HANDY MAN	Del Shannon
16.	REMEMBER	Shangri-La's
17.	AIN'T SHE SWEET	Beatles
18.	BECAUSE	Dave Clark Five
19.	TELL ME	Rolling Stones
20.	DON'T WORRY BABY	Beach Boys
21.	A QUIET PLACE	Garnet Mimms
22.	LITTLE OLD LADY	Jan & Dean
23.	I BELIEVE	Bachelors
24.	KEEP ON PUSHING	Impressions
25.	DAVID'S MOOD	Kingsmen

WFEC DISK-COVERY: Pretty Woman—Roy Orbison

WFEC *Summer* **TEEN**

DANCES *are in Full*

SWING! *Dial* **1400**

for this week's locations

This WFEC (1400) music survey from August 15, 1964, featured the faces of the station's air staff: Lucky Pierre, Buzz A. Long, Buddy Carr, Curt Whitcomb, Johnny Garland, Dave Marino, and Dick Bradley. The artists on the survey included the Beatles, the Supremes, the Animals, and the Rolling Stones. (Courtesy of author's collection.)

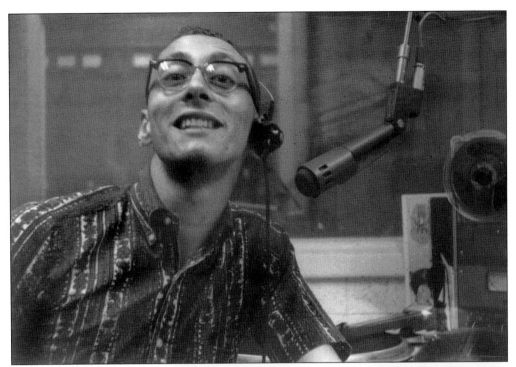

Bill Kauffman is a veteran Harrisburg broadcaster. He was part of the WCMB lineup in the mid-1960s that included Ed Gonzalez, GoGo Gale, Red McCarthy, and Pete Wambach. Kauffman was present for the sign-on of WCMB-FM (99.3). He joined the staff at WHP in 1971, where he was on the air until 1979. "Doctor Bill" is presently an engineer at WGAL. (Courtesy of Bill Kauffman.)

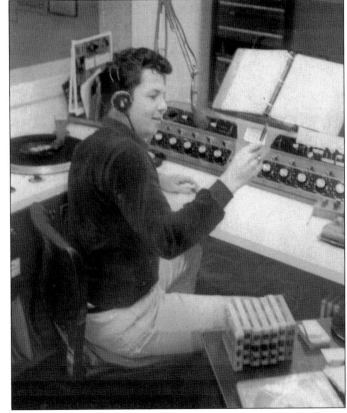

Ben Barber was a WCMB disc jockey in the 1960s. At present, he is on WHYL 960 AM in Carlisle. (Courtesy of Bill Kauffman.)

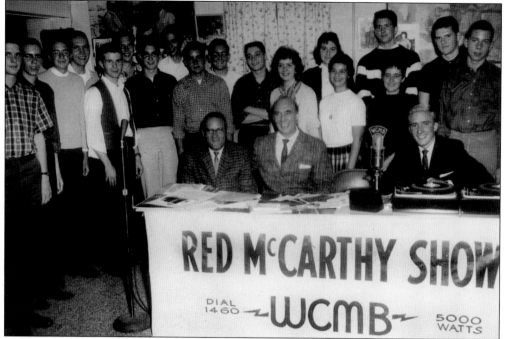

Red McCarthy was part of the lineup on WCMB in the 1960s and 1970s. McCarthy had a conversational style that was typical of MOR (middle-of-the-road) announcers. He is seated in the middle with his son Jimmy seated to his right. (Courtesy of author's collection.)

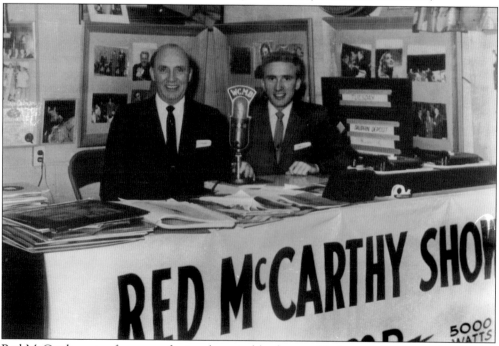

Red McCarthy came from a professional musical background before getting into radio. On his show, McCarthy played adult standards from artists like Anita Bryant, Ed Ames, and Les Brown and His Band of Renown. Red is pictured with his son Jimmy. (Courtesy of author's collection.)

Seven

THE 1970s

The 1970s were the decade of Hurricane Agnes and Three Mile Island.

Hurricane Agnes struck the East Coast of the United States in June 1972. It caused extensive damage as it moved up the coast from Florida. Harrisburg and other communities along the banks of the Susquehanna River experienced devastating flooding by the time the storm reached the Mid-Atlantic. In the days that followed, local radio and television stations played a critical role in keeping the public informed about the extent of the flood damage and the state of relief efforts.

In 1979, the Three Mile Island Nuclear Generating Station near Middletown (several miles south of Harrisburg) became the site of the nation's worst commercial nuclear accident. During the early morning hours of March 28, a water pump failed in unit two, ultimately resulting in a partial meltdown of nuclear fuel rods and a release of radiation from the plant. As the story developed, local radio and television once again proved to be an indispensable source of information as authorities sorted out the seriousness of the accident.

WKBO is widely credited with breaking the Three Mile Island (TMI) story to the national media thanks to the persistence of news director Mike Pintek and the attentive eye of traffic reporter "Captain Dave" Ratcliffe. On the morning of the accident, unusual activities at TMI caught Ratcliffe's attention as he drove near the plant. Using his two-way radio, Ratcliffe contacted Pintek in the news room about his observations. In turn, Pintek called TMI to get an explanation of what was happening. After initially getting no cooperation on the other end of the line, Pintek eventually received confirmation that a serious nuclear event had indeed occurred at the plant. Within hours, the entire country had heard of Three Mile Island for the first time.

A new local radio station went on the air in late 1978: WQVE, 93.5 (MHz) in Mechanicsburg. It was owned by West Shore Broadcasting. The station was later known as WKCD for several years before becoming WTPA in 1985, taking the legacy call letters (and the album rock format) from FM104 in Harrisburg.

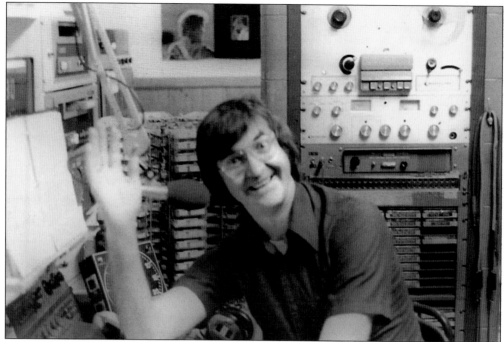

A native of Beaver Falls, Pennsylvania, Bob Alexander was WKBO's program director from 1972 to 1975. "Klep" (which is short for his actual last name, Klepic) turned the low-rated station into a Top-40 powerhouse known as "the Rock of Harrisburg" starting in February 1972. WKBO's ratings soared and put the station up against more powerful, "middle-of-the-road" stations like WHP and WCMB. (Courtesy of Dave Ratcliffe.)

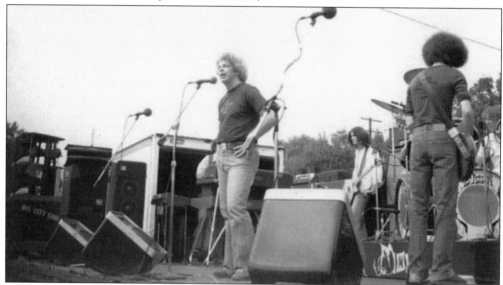

WKBO's Dan Steele made this station appearance on City Island around 1975. Steele, a native of Trenton, New Jersey, began his radio career at WKBO in 1971. After two years in Washington, DC, Steele returned to Pennsylvania in 1975 and has been a mainstay of Harrisburg radio ever since. Steele became the producer of the *R.J. Harris in the Morning* show on WHP 580 in May 2004. (Courtesy of Dan Steele.)

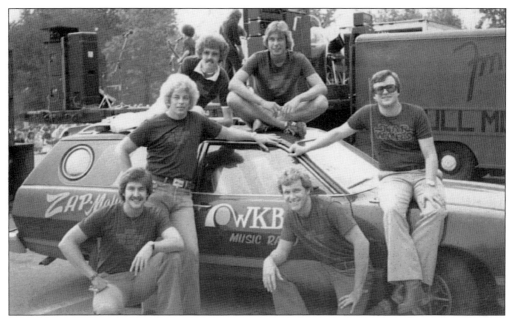

WKBO's air staff appeared at this concert on City Island around 1975. Clockwise from the left are John St. John, Dan Steele, Jim Buchanan, Chris Andree, Mike Pintek, and Rick Shockley. As of 2010, all of them were still working in broadcasting. Steele, Andree, and Buchanan were in the Harrisburg-York area. Pintek went to KDKA in Pittsburgh. St. John moved to New Orleans, and Shockley headed to Florida. (Courtesy of Dan Steele.)

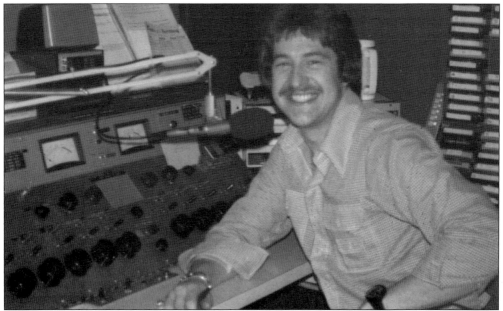

WKBO's John St. John was born Micheal Ziants of Newcastle, Pennsylvania, in 1952. Ziants was hired by WKBO program director Bob Alexander in 1973. In 1978, "Saint John" headed for St. Louis after a highly successful run with his afternoon show on WKBO. He subsequently worked at stations in Nashville, Philadelphia, and New Orleans in the early 1980s. He currently runs Airlift Productions, a recording and voice-over service in New Orleans. (Courtesy of Mike Ziants.)

MUSIC WKBO 1230 RADIO

The Best Music

LW	TW	TITLE	ARTIST
		WEEK OF APRIL 10, 1978	
2	1	THE GOOD-BYE GIRL . . . David Gates	
15	2	FLASHLIGHT Parliment	
1	3	CAN'T SMILE WITHOUT YOU Barry Manilow	
4	4	IF I CAN'T HAVE YOU . . Yvonne Elliman	
14	5	LET'S ALL CHANT . . . Michael Zager Band	
8	6	WHICH WAY IS UP? Stargard	
9	7	THANK YOU FOR BEING A FRIEND Andrew Gold	
10	8	THE CLOSER I GET TO YOU Flack & Hathaway	
19	9	FEEL SO GOOD Chuck Mangione	
11	10	WE'LL NEVER HAVE TO SAY GOODBYE AGAIN . . England Dan & John Ford Coley	
12	11	LADY LOVE Lou Rawls	
7	12	RUNNING ON EMPTY . . . Jackson Browne	
17	13	DISCO INFERNO Trammps	
5	14	NIGHT FEVER Bee Gees	
16	15	FOOLING YOURSELF Styx	
6	16	EBONY EYES Bob Welch	
13	17	SWEET TALKING WOMAN E.L.O.	
23	18	COUNT ON ME Jefferson Starship	
20	19	IMAGINARY LOVER Atlanta Rhythm Section	
26	20	MOVIN' OUT Billy Joel	
28	21	WITH A LITTLE LUCK Wings	
18	22	JACK & JILL Raydio	
25	23	EVERY KINDA PEOPLE . . . Robert Palmer	
27	24	BEFORE MY HEART FINDS OUT Gene Cotton	
FH	25	I'M GONNA TAKE CARE OF EVERYTHING. Rubicon	
FH	26	TWO DOORS DOWN Dolly Parton	
29	27	THIS TIME I'M IN IT FOR LOVE . . . Player	
FH	28	WEREWOLVES OF LONDON. . Warren Zevon	
KBO	29	I WANT YOU TO BE MINE Kayak	

FUTURE HITS
YOU'RE THE ONE THAT I WANT
John Travolta/Olivia Newton John
EGO Elton John
IT'S A HEARTACHE Bonnie Tyler

The WKBO Music Guide is assembled by using information derived from WKBO's sources, both national and local, and WKBO's evaluations of the potential sales and growth of each song. The Music Guide is subject to the accuracy of its sources.

The Best Albums

1. SATURDAY NIGHT FEVER . Original Soundtrack
2. RUNNING ON EMPTY Jackson Browne
3. FUNKENTELECHY VS. PLACEBO SYNDROME. Parliment
4. THE STRANGER Billy Joel
5. LONDON TOWN Wings
6. GRAND ILLUSION Styx
7. POINT OF KNOW RETURN Kansas
8. FEEL SO GOOD Chuck Mangione
9. EVEN NOW Barry Manilow
10. EARTH Jefferson Starship

MUSIC RADIO WKBO WHERE BY POPULAR DEMAND THE "KBO COCA-COLA" DEDICATION HOUR HAS RETURNED. BE LISTENING FOR YOUR CHANCE TO DEDICATE YOUR FAVORITE RECORD NIGHTS FROM 7 TO 8 WITH BIG JIM ROBERTS.

WKBO MUSIC RADIO

Coming Soon
THE GREAT

KBO COUPON CAPER

LOOK FOR ENTRY COUPONS IN YOUR LOCAL NEWSPAPER OR SEND A POST CARD WITH YOUR NAME, ADDRESS AND TELEPHONE NUMBER TO WKBO, 411 S. 40TH ST., HARRISBURG, PA 17111. THEN BE LISTENING FOR YOUR NAME ON THE AIR. IT'S YOUR FIRST STEP TO WIN BIG FROM

MUSIC RADIO

MUSIC WKBO RADIO Is Harrisburg

This music sheet from April 10, 1978, featured WKBO jock "Big" Jim Roberts. The Top-40 hits on WKBO at the time included songs by David Gates, Yvonne Elliman, Barry Manilow, Billy Joel, and Styx. (Courtesy of author's collection.)

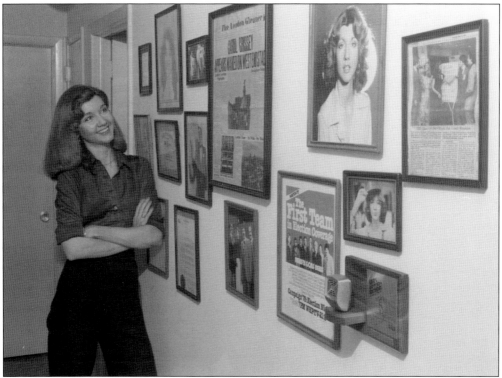

Carol Crissey was paired with Dan Steele at WKBO in 1975, forming the first male-female morning show in Harrisburg. After several years, the Troy, New York, native resumed her news career and joined WHP-TV in 1978. She retired from WIVB in Buffalo, New York, in 2002 after more than two decades as a news anchor. (Courtesy of the Historical Society of Dauphin County.)

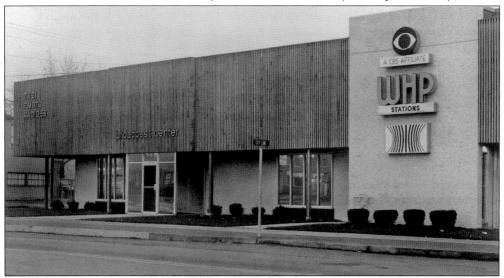

The WHP stations moved from the Telegraph Building on Locust Street in downtown Harrisburg to 3300 North Sixth Street on the Harrisburg-Susquehanna Township border in 1975. (The operation on Locust Street began as a single station in 1930 and grew to include WHP-FM in 1946 and WHP-TV in 1953.) (Courtesy of R.J. Harris.)

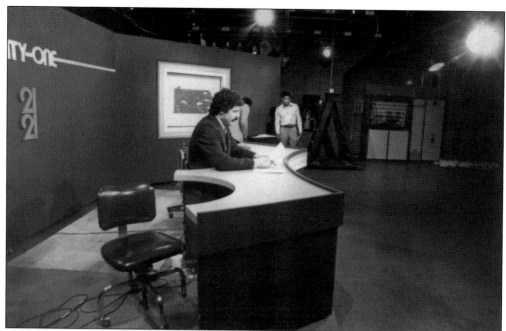

WHP-TV viewers from the mid-1970s will recognize newscaster Tom Sinkovitz. Sinkovitz worked at WKBO in the early 1970s. After WHP, he worked in Cincinnati, Baltimore, and Atlanta. Presently, he is an anchor for the NBC affiliate in San Francisco. His twin brother, Jim Sinkovitz, is currently with WGAL in Lancaster. (Courtesy of R.J. Harris.)

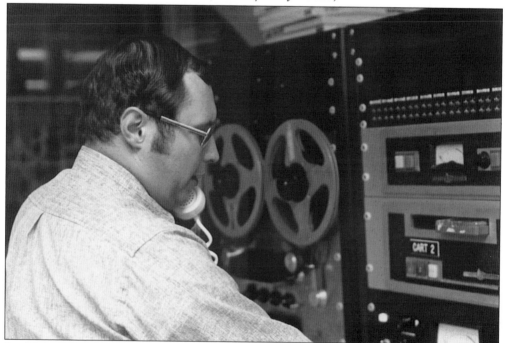

Jim Moyer was the news anchor on Ron Drake's morning show on WHP for many years. Moyer left the station in the early 1980s and was a district justice near Harrisburg until his passing in the 2000s. (Courtesy of R.J. Harris.)

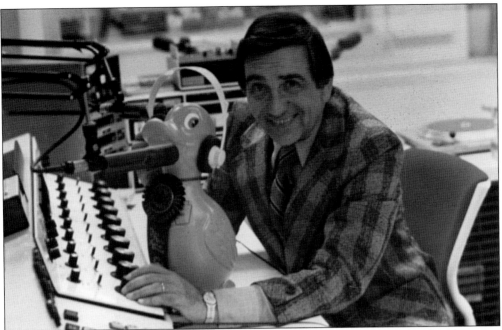

WHP's Ron Drake poses with his famous rubber ducky. Drake's morning radio show began in 1960 and continued until his retirement in 1982. He was especially known for his outlandish April Fools' Day pranks and his unpredictable man-on-the-street interviews. Drake passed away in Florida in December 2005 at the age of 85. (Courtesy of R.J. Harris.)

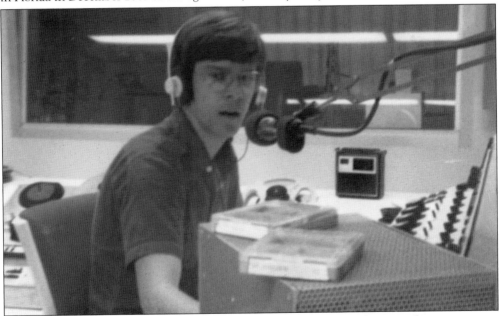

Brian Freeman was a staff announcer at WHP from 1975 and 1981. He functioned as a newscaster, traffic reporter, and program host. From 1982 to 1997, Freeman owned and operated a Harrisburg-based traffic and news reporting service for radio. He also served as the morning host on the short-lived B97.3 (WXBB) in the early 1990s. Freeman's career took him to stations in the South starting in 2000. (Courtesy of Brian Freeman.)

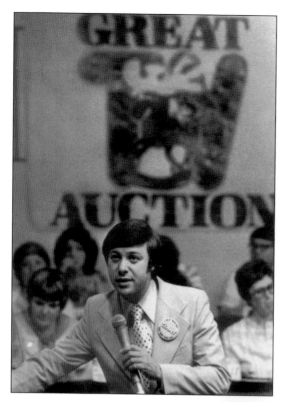

If public television in Central Pennsylvania had a single, recognizable face, it would be that of WITF's Mike Greenwald. Over his 43-year career, the New York City native served as a host, producer, director, public relations director, and development director for WITF. Greenwald managed a $19-million fundraising campaign that helped build WITF's Public Media Center, which opened in 2006. He retired in 2007 as a senior vice president. (Courtesy of WITF.)

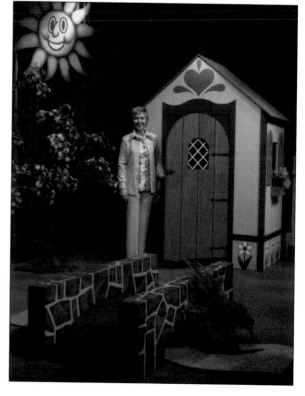

Broadcasting pioneer Marijane Landis started at WGAL in 1952. She served in a number of capacities, including writer, producer, host, and personnel director during her 41-year career, but she will always be associated with hosting children's shows like *Percy Platypus and His Friends* and *Sunshine Corners*. Landis retired in 1993 and was inducted into the Pennsylvania Association of Broadcasters Hall of Fame in 1998. (Courtesy of WGAL.)

WTPA's news crew in the late 1970s included (from left to right) sportscaster Vince DeLisi, weatherman Chuck Rhodes, and anchor Richard Seneca. Seneca was born in Harrisburg and worked for WHP and WFEC in the mid-1970s. He started with WTPA-TV in 1978 and moved to WHP-TV in 1982. Seneca became an attorney in Central Pennsylvania in 1987. (Courtesy of Chuck Rhodes.)

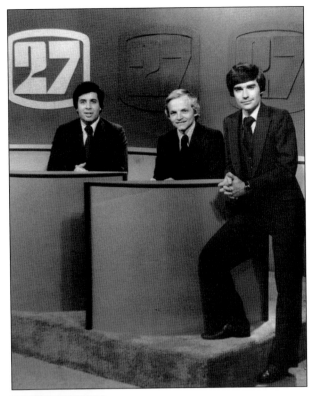

Roxanne Stein was a news anchor for WGAL from 1978 to 1981. After leaving the region, Stein worked in Pittsburgh and Tennessee during the 1980s. She returned to the area to coanchor *Newsight 21* for WHP-TV, replacing Kathy Reilly. (Courtesy of WGAL.)

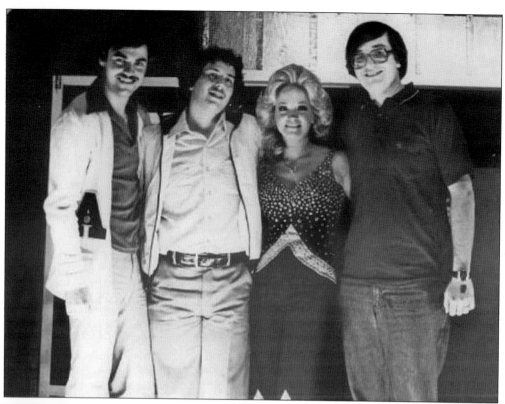

WFEC (1400) had been a Top-40 station throughout the 1960s and 1970s when it switched to a country format in early 1977. This picture from 1978 shows (from left to right) air staffers Tony Bonvini, Barry "Glen Barrie" Mardit, and Vince Grant with country singer Barbara Mandrell. The format lasted until mid-1978. The station has been through a succession of formats including disco, "hot hits," adult standards, Christian, urban, and sports talk. (Courtesy of Tony Bonvini.)

The beautiful architecture of Market Square Presbyterian Church has been a fixture in Harrisburg since 1860. The church's pastor during the 1960s, Rev. John Tate, had the vision to use radio to reach out to the community with fine, noncommercial programming. With the assistance of a group of supporters, WMSP was a reality by 1962. The studios occupied several classrooms. The station antenna was located on the top of the steeple. (Photograph by Tim Portzline, 2010.)

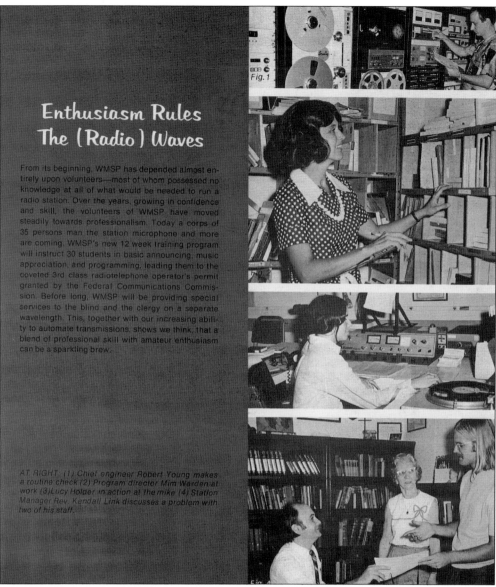

Enthusiasm Rules The (Radio) Waves

From its beginning, WMSP has depended almost entirely upon volunteers—most of whom possessed no knowledge at all of what would be needed to run a radio station. Over the years, growing in confidence and skill, the volunteers of WMSP have moved steadily towards professionalism. Today a corps of 35 persons man the station microphone and more are coming. WMSP's new 12 week training program will instruct 30 students in basic announcing, music appreciation, and programming, leading them to the coveted 3rd class radiotelephone operator's permit granted by the Federal Communications Commission. Before long, WMSP will be providing special services to the blind and the clergy on a separate wavelength. This, together with our increasing ability to automate transmissions, shows we think, that a blend of professional skill with amateur enthusiasm can be a sparkling brew.

AT RIGHT, (1) Chief engineer Robert Young makes a routine check (2) Program director Mim Warden at work (3) Lucy Holder in action at the mike (4) Station Manager Rev. Kendall Link discusses a problem with two of his staff.

Fig. 1

WMSP published a booklet about the station's history and mission in the early 1970s. More than 100 volunteers from the community operated WMSP. They handled just about every chore: selecting music, announcing, producing, fundraising, and designing the program guide. In the top right photograph is chief engineer Bob Young, followed by program director Mim Warden, announcer Lucy Holder, and manager Kendall Link (seated). (Courtesy of Lucy Holder McConaghie.)

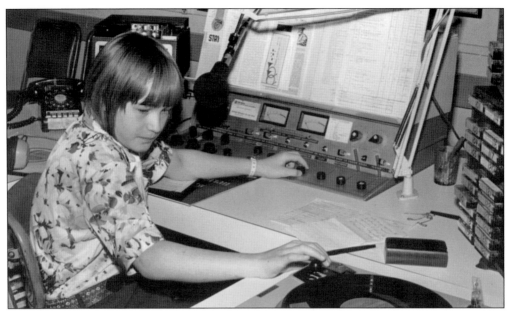

The *Patriot-News* ran an article on April 21, 1976, about the author of this book, who earned his FCC Third Class Radiotelephone License while volunteering at WMSP in 1975. At that time, an FCC license was necessary to operate a radio station transmitter. It was extremely rare for a preteen to have such a license. (© 1976 the *Patriot-News*. All rights reserved. Reprinted and used with permission of the *Patriot-News*.)

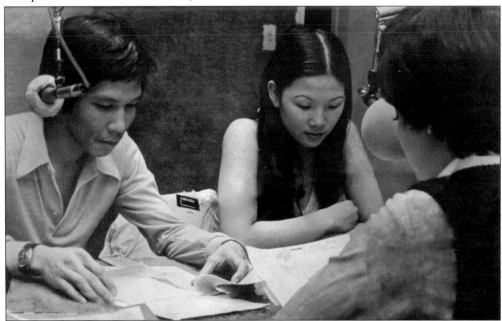

WMSP cut across cultural boundaries with very diverse programming. One of the station's weekly features was *Spirit of Vietnam*, produced at WMSP by (pictured from left to right) Le Thanh Lang, Loan Nguyen, and Hanh Ho Truong. The show was part of an outreach by the Market Square Presbyterian Church to the growing Vietnamese community in the Harrisburg area during the 1970s. (Courtesy of Wilmer Henninger.)

Eight

THE 1980S

The 1980s were a busy time in Harrisburg Broadcasting. For starters, WTPA-TV (Channel 27) was purchased by the Times-Mirror Company from Newhouse in 1980. (Newhouse also owned the *Patriot-News*.) The station dropped the WTPA call letters in favor of WHTM for "Harrisburg Times-Mirror." Newhouse retained ownership of WTPA-FM (FM104) until 1982 when it was sold to Foster Media. FM104 was sold again in 1984 to Keymarket Communications.

FM104 became WINK104 (WNNK) in January 1985. The kickoff included a huge on-air celebration. WINK's ratings skyrocketed almost overnight thanks to a fresh approach to Top-40 radio and enjoyable (sometimes over-the-top) air personalities. Bruce Bond was the station's first program director and the outspoken afternoon disk jockey. Tim Burns hosted the morning show along with newscaster Dennis Edwards and "the Joke Lady," Sue Campbell.

When WINK104 launched in 1985, FM104's album rock format (and the WTPA call letters) were traded with 93.5 MHz in Mechanicsburg in a deal arranged by the husband-and-wife team of Jim and Carol O'Leary. (Jim was part owner of WKCD in Mechanicsburg, and Carol was the general manager of FM104 in Harrisburg.)

WKBO dropped its Top-40 format during the 1980s, leaving behind the programming that made it highly successful just a decade before. It marked the end of an era in Harrisburg. Many AM stations across the country moved from Top 40 during this period as FM became the dominant medium for music. The glory days of AM radio were over.

A serious event affecting local radio and TV journalists took place on January 22, 1987. Pennsylvania state treasurer R. Budd Dwyer used a pistol to take his life at a press conference in Harrisburg. Dwyer had recently been prosecuted in Williamsport, Pennsylvania, of taking a bribe in a no-bid state contract. He was about to be sentenced the next day. The press conference was expected to be his resignation speech. After delivering a lengthy, wandering statement, Dwyer pulled a gun from an envelope. Horrified onlookers began yelling things like, "Budd, don't!" Dwyer ignored them and pulled the trigger. The outcome of that day still reverberates in the hearts of Dwyer's family and in the minds of the helpless witnesses who watched the horror unfold. That day was a snow day for local school children. Several Harrisburg stations broke into programming and showed the entire shooting sequence on the air, prompting furious complaints from parents.

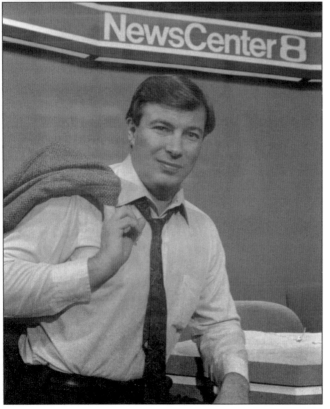

Kim Lemon and Josh Hooper were the original hosts of WGAL's *PM Magazine* in 1980. The program featured lifestyle stories about local events and attractions. Lemon, a Lancaster native, became a fulltime news anchor for WGAL in 1985 while continuing to cohost the show. Hooper, who studied at Franklin & Marshall College in Lancaster, moved on to a career in television production and marketing in 1983. (Courtesy of WGAL.)

Keith Martin was a news anchor for WGAL throughout the 1980s. Martin worked at WBRE in Wilkes-Barre–Scranton in the 1970s and returned to WBRE after leaving WGAL in 1990. (Courtesy of WGAL.)

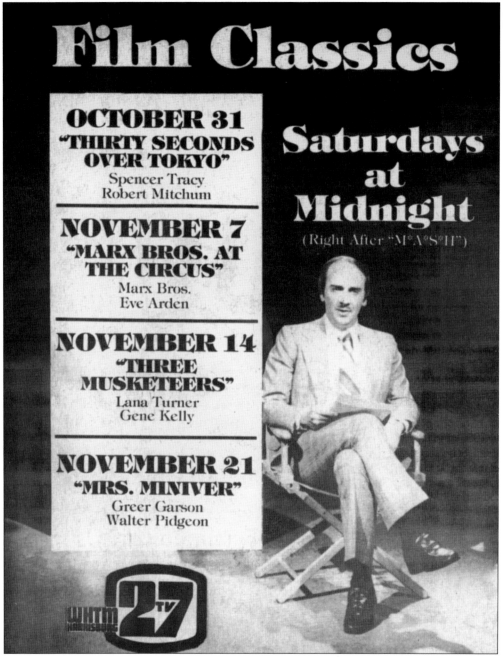

Film Classics

OCTOBER 31
"THIRTY SECONDS OVER TOKYO"
Spencer Tracy
Robert Mitchum

NOVEMBER 7
"MARX BROS. AT THE CIRCUS"
Marx Bros.
Eve Arden

NOVEMBER 14
"THREE MUSKETEERS"
Lana Turner
Gene Kelly

NOVEMBER 21
"MRS. MINIVER"
Greer Garson
Walter Pidgeon

Saturdays at Midnight
(Right After "M*A*S*H")

WHTM HARRISBURG 27 TV

Paul Baker was WHTM's programmer and host of *Film Classics* in the early 1980s. Baker was also known for his radio work at WHP 580 and, later, at WHYL in Carlisle. (Courtesy of WHTM.)

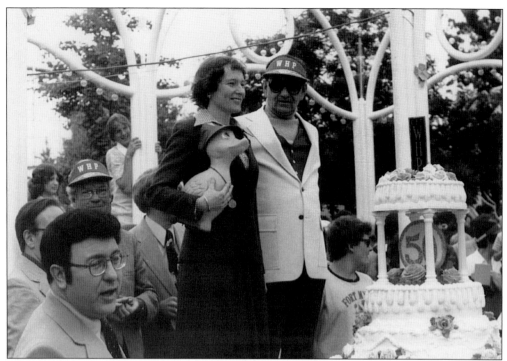

WHP celebrated its 50th anniversary in 1980 with a large celebration at Hershey Park. Ron Drake was joined by Pennsylvania first lady Ginny Thornburgh. WHP newsman John Sebastian is in the bottom left of the photograph. (Courtesy of R.J. Harris.)

In this photograph from WHP's 50th anniversary are, from left to right, legendary morning host Ron Drake, station manager Joe Higgins, air personality Bob Alexander, and engineer Nelson Maus. The station used 1930 as the basis for this anniversary, which coincided with the year that the Stackpole family began operating WHP. Historical records indicate that WHP radio actually started in 1925 as WHBG. (Courtesy of R.J. Harris.)

This is the classic WTPA FM104 logo that was seen on billboards, bumper stickers, and other promotional materials in the 1980s. Among FM104's air staff was Jeff Kauffman, Torre, Jay Smith, and Elton Cannon. The station's album rock format and call letters moved to 93.5 in Mechanicsburg (formerly WQVE and WKCD) and 104.1 became WINK 104 (WNNK) in a coordinated swap in January 1985. (Courtesy of Dennis Gerkin.)

Jeff "the Jammer" Kauffman was a veteran of album rockers FM104 and 93.5 WTPA. He was part of the on-again, off-again *Coffey and the Jammer* morning show for many years. Kauffman died of a heart attack on March 2, 2007, at age 57. The morning show (which included Amy Warner) had just rejoined the WTPA lineup one month before Kauffman's death. (Courtesy of Bruce Bond.)

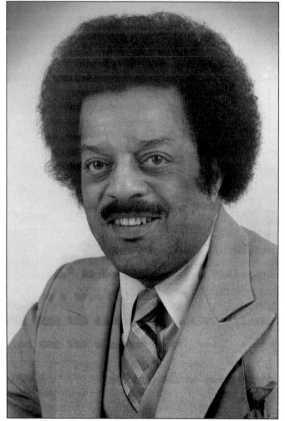

The WCMB-WSFM building in Wormleysburg was a West Shore landmark for many years. The original structure, built in 1948, was a simple block building that served as WCMB's transmitter shelter. Eventually, studios, offices, and a new exterior were added. The building sat vacant after the stations were sold in the 1990s, and the equipment was moved elsewhere. The towers were razed in March 2001. The building was demolished in May 2010. (Photograph by Tim Portzline, 1984.)

George "Toby" Young is probably best known as the host of *Echoes of Glory* on WTKT (formerly WCMB). However, Young hosted numerous radio and television programs during his career, including cohosting the March of Dimes Telethon on WTPA television. Young retired from a 30-year career with the Pennsylvania Civil Service Commission and holds a master's degree in human services from Lincoln University. (Courtesy of George Young.)

Bill Trousdale hosted *Lunchtime at the Oldies* on WKBO in the early 1980s. Prior to coming to Harrisburg, Trousdale worked at stations scattered around New York, New Jersey, and Pennsylvania, including WPEN in Philadelphia. After WKBO, Trousdale was an account executive for WWKL in Harrisburg and WSOX in York. (Courtesy of Bill Trousdale.)

WKBO's news crew in the mid-1980s included (from left to right) Don Rooney, Colleen Mance, Dennis Edwards, and Michael Parks. Rooney was a weather anchor on WHP-TV in the 1990s. Edwards handled morning news on WINK 104 for several years and hosted the morning show on WHP 580 in the 1990s. Parks has been a radio program host, producer, and commercial writer in Harrisburg for many years. (Courtesy of Dennis Gerkin.)

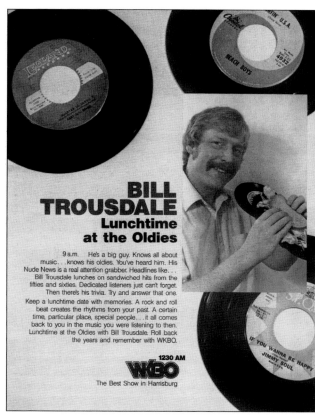

BILL TROUSDALE
Lunchtime at the Oldies

9 a.m. He's a big guy. Knows all about music... knows his oldies. You've heard him. His Nude News is a real attention grabber. Headlines like... Bill Trousdale lunches on sandwiched hits from the fifties and sixties. Dedicated listeners just can't forget. Then there's his trivia. Try and answer that one.

Keep a lunchtime date with memories. A rock and roll beat creates the rhythms from your past. A certain time, particular place, special people... it all comes back to you in the music you were listening to then. Lunchtime at the Oldies with Bill Trousdale. Roll back the years and remember with WKBO.

WKBO 1230 AM
The Best Show in Harrisburg

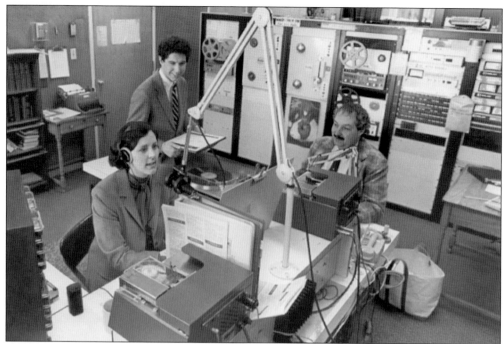

WMSP (94.9) was unique. It was a noncommercial, church-owned station operated by a staff of nearly all volunteers from its beginning in 1962. By 1985, financial difficulties made it necessary for the station to bend its rules, hire an announcing staff, and begin playing commercials. This photograph from 1985 shows Edie Miller (left), station manager Dave Zett (right), and Art Stewart (middle) in the air studio. (Courtesy of Wilmer Henninger.)

The lineup on WINK 104 in the late 1980s included (from left to right) afternoon personality and program director Bruce Bond, assistant program director and midday disk jockey Allen Price, and morning show host Tim Burns. (Courtesy of Bruce Bond.)

Harrisburg radio veteran Dan Steele (right) made guest appearances on WINK in the 1980s. Steele was known for having white hair, which Bruce Bond poked fun at by putting on a white clown wig in this photograph. (Courtesy of Bruce Bond.)

Pictured from left to right, Dennis Edwards was WINK 104's news anchor on the morning show with Tim Burns and Sue Campbell from 1985 to 1991. Edwards later moved to WHP 580 as an operations manager and morning show host from 1992 to 1997. (Courtesy of Dennis Gerkin.)

One of the benefits of working in broadcasting is rubbing elbows with celebrities. In this photograph from the 1980s, WINK 104 air personalities Bruce Bond (left) and Ed August pose with singer Amy Grant. Grant is mainly known for writing and performing contemporary Christian music, but her early-1990s pop album *Heart in Motion* scored several big hits that received airplay on WINK. (Courtesy of Bruce Bond.)

Pictured from left to right, Chris James and Torre (pronounced "tor-ee") were part of the air staff at 93.5 WTPA in 1985. WTPA signed on in the late 1970s as WQVE, owned by West Shore Broadcasting. It operated from a double-wide trailer in Mechanicsburg. After several years as WKCD, the station became album rock WTPA in 1985. The call letters are a legacy of WTPA-TV (now WHTM) and WTPA-FM (now WNNK) in Harrisburg. (Courtesy of Rich Hill.)

Nine

THE 1990s

The 1990s were the decade of radio consolidation. The FCC loosened the restriction on the number of stations that an owner could have in one city. Stations grouped and regrouped, so that, by 1997, Dame Media owned WRVV (97.3), WRBT (94.9), WWKL-FM (99.3), WHP (580), WWKL-AM (1460), and WKBO (1230). Clear Channel then purchased the group in 1999.

Across town, WNNK (104.1) and WTCY (1400), a combination since 1989, were paired with WTPA (93.5) and WCTX (92.1) under station owner AM/FM. The cluster would eventually be taken over by Cumulus in the early 2000s.

Bruce Bond's career with WINK 104 (WNNK) came to a halt in 1990 after Bond was accused of making a racially insensitive remark on the air. Bond returned to WINK in 1992.

WHP-FM became the River (WRVV) in March 1992 with programmer Chris Tyler at the helm. The format was based on a unique blend of popular rock and classic rock.

Commonwealth Communications sold the WHP stations in the early 1990s. Clear Channel ultimately purchased WHP-TV in 1995 and the Dame Media cluster, which included WHP-AM and WRVV, in 1999. The WHP stations were essentially back together again under Clear Channel, although the facilities remained separate.

Oldies format KOOL (WWKL) moved from 94.9 to 99.3 MHz in 1995, and WKBO's transmitter moved from Harrisburg's City Island to a location near the Farm Show Complex in 1996. The old tower and transmitter building, landmarks since 1973, were demolished.

Pictured here in 1994 is the WRVV-WHP minicar with, from left to right, River program director Chris Tyler and station staffers Bill Rehkopf, Penny Kireta Meyer, Scott Matthews (seated in car) and Brandon LaVage. (Courtesy of Chris Tyler.)

Posing in this early-1990s photograph are KOOL air staffers (clockwise, beginning far left) Nancy Ryan, Tod Jeffers, Brian Williams, Tim McCauley, Chris Andree, Jay Smith, and Tom Shannon. (Courtesy of R.J. Harris.)

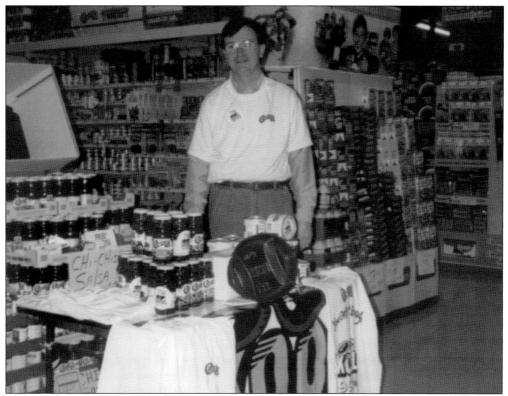

Veteran Harrisburg Broadcaster Scott "Scooter" Fortney made this personal appearance at a remote broadcast for KOOL (99.3 WWKL) in the late 1990s. Fortney's career took him from WCMB-WSFM in the late 1970s to KISS 95 (WHKS) and KOOL 94.9. Fortney currently runs a successful voice-over business from his home. (Courtesy of R.J. Harris.)

WTPA (93.5) ran this billboard campaign when the station underwent major transmission improvements in 1992. (Courtesy of Rich Hill.)

Scott "the Hitman" Shaw from WINK 104, is pictured here around 1990. Shaw grew up in Cranberry, Pennsylvania, in the 1960s and 1970s. Shaw held evening and midday on-air shifts during his time at WINK from the 1980s into the 1990s. More recently, Shaw produced statewide sports call-in shows, such as *Speaking of Sports* for former Harrisburg broadcaster Jed Donahue. (Courtesy of author's collection.)

Flora Posteraro came to WHTM in 1997 by way of WPVI in Philadelphia. She is currently a news anchor. Previously, she worked for stations in West Virginia, Johnstown, and Wilkes-Barre. Posteraro studied at California University in Pennsylvania. (Courtesy of WHTM.)

Rick Wagner was a familiar face on WHTM for many years. He was the lead news anchor from 1982 until his departure in the mid-2000s. Wagner studied in Minnesota and worked in DuBuque, Iowa; Minneapolis, Minnesota; and Springfield, Missouri, before coming to WHTM. (Courtesy of WHTM.)

Valerie Pritchett has been with WHTM since 1993. Prior to that, Pritchett studied at Stockton State College and worked at WMGM-TV in New Jersey. (Courtesy of WHTM.)

From left to right, WGAL anchors Dick Hoxworth, Keith Martin, Kim Lemon, and Ron Martin pose with NBC's Tom Brokaw around 1990. (Courtesy of WGAL.)

Dennis Edwards and Melanie Apple were the lighthearted duo of the morning on WHP 580 in the 1990s. Prior to WHP, Edwards handled news at WKBO and WINK 104. Apple passed away in the mid-2000s. (Courtesy of Dennis Edwards.)

KOOL's Nancy Ryan and WHP-TV news anchor Gene Lepley made an appearance together at this event at Strawberry Square. (Courtesy of R.J. Harris.)

Tod Jeffers and Nancy Ryan of BOB 94.9 (WRBT) are pictured during a live broadcast around 1997. (Courtesy of R.J. Harris.)

From left to right, WINK 104 personalities Hollywood Heffelfinger, Tim Burns, and Sue Campbell are pictured at a station event in the mid-1990s. (Courtesy of Tom Walker.)

Bruce Bond was honored with the 1996 National Association of Broadcasters Medium Market Personality of the Year Award. (Courtesy of Bruce Bond.)

Ten

2000 AND BEYOND

The first decade of the new millennium brought many technological changes to broadcasting.

Over-the-air analog television transmissions became a thing of the past in 2009 for many TV stations across the country. The discontinuation of analog TV was the final phase of a lengthy conversion to digital technology that began in 1996.

The purpose of the digital television (DTV) transition was two-fold. First, it allowed the FCC to free up frequencies that could be auctioned off for new communication services. Second, it gave television stations the ability to transmit high-resolution video and secondary TV channels never possible with analog technology.

The migration to DTV made it necessary for TV stations to replace millions of dollars of equipment, such as transmitters, antennas, cameras, video recorders . . . pretty much everything that makes a TV station work. With DTV in mind, WITF built a beautiful new Public Media Center in Swatara Township in 2006.

The radio industry also benefited from new technology with the advent of wireless internet streaming and HD Radio. Wireless Internet devices make it possible for radio stations to be heard by anyone nearly anywhere in the country. Traditional signal boundaries have essentially become a thing of the past thanks to streaming audio via the Internet.

HD Radio gives radio stations the option to transmit a high-quality digital signal along with their conventional analog broadcasts. FM stations benefit from the ability to broadcast extra audio channels with near-CD quality. Many Harrisburg area stations adopted HD Radio in the mid-2000s, with WINK104 and the River 97.3 leading the way in 2004. A drawback to HD Radio is that it requires a special radio to receive it.

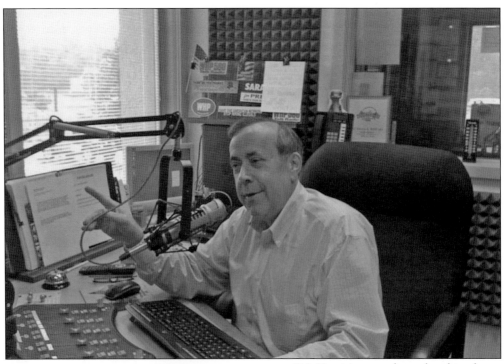

R.J. Harris's career has taken him from his native Reading, Pennsylvania, to Harrisburg, Philadelphia, Sacramento, Nashville, Chicago, New York City, and back to Harrisburg again. Harris has been the host of WHP 580's highly successful *R.J. Harris in the Morning* show since 2000. In 2010, Harris wrote *It Ain't Easy Being Fat, But That's Your Problem*, a frank book about his struggle with weight loss. (Courtesy of R.J. Harris.)

Conservative talk show host Bob Durgin has a way with words. One of his favorite phrases on his WHP 580 show is, "Shut up and pay your taxes!" Born in Boston, Durgin's career has taken him to stations in Texas, Oklahoma, and Kansas. Durgin arrived in Harrisburg in 1989 and has been voted Simply the Best Talk Show Host by *Harrisburg Magazine*. (Courtesy of WHP.)

Olin Harris received a Lifetime Achievement Award from the Pennsylvania Association of Broadcasters in 2008. Olin's daughter Kirsten Nicole Harris and grandson Christopher Harris were in attendance. Kirsten said of her father, "When it came to injustice, prejudice or discrimination against anyone, Dad's big voice of justice, equality, freedom for all . . . resounded from his microphone to every mountaintop and in the way he lived his life." (Courtesy of the Harris Family Library.)

WINK 104's air staff greets singer Rob Thomas in this photograph from 2008. Pictured from left to right are morning personality Denny Logan, Cumulus operations manager John O'Dea, Thomas, afternoon personality Hollywood Heffelfinger, morning cohost Sue Campbell, and air personality John Beaston. (Courtesy of Dave Hendry.)

WGAL's Janelle Stelson started in the Harrisburg-Lancaster-Lebanon-York market at WHTM as a weather anchor in the 1980s. (Courtesy of WGAL.)

A native of York, Pennsylvania, Ron Martin has been with WGAL since 1983. He began his career at NBC News in Washington, DC. After Martin earned a bachelor of arts degree in communications at Howard University, his career took him to WSBA in York and WHP-TV as a reporter. He became a permanent weeknight anchor on WGAL in 2000. (Courtesy of WGAL.)

Sherry Christian and Steve Knight were morning news anchors on WHP-TV in 2010. (Courtesy of WHP-TV.)

Pictured from left to right, in 2010, WHP-TV's evening anchor lineup included sports anchor Jason Bristol, news anchors Robb Hanrahan and Tanya Foster, and meteorologist Tom Russell. (Courtesy of WHP-TV.)

During his 50-year career with WHTM (previously WTPA), Mike Ross served as an anchor, news director, legislative correspondent, and telethon cohost. He even acted in several made-for-television productions. He earned the Television Broadcaster of the Year Award from the Pennsylvania Association of Broadcasters in 1998. Ross retired in 2002 and passed away in 2006 at age 83 following a courageous battle with Lou Gehrig's disease. (Courtesy of WHTM.)

Gregg Mace joined WHTM (then WTPA) as a sports anchor in 1979. Prior to his arrival in Harrisburg, Mace worked in Syracuse, New York; Hastings, Nebraska; and Bel Air, Maryland. (Courtesy of WHTM.)

Dennis Owens started at WHTM as a weekend sports anchor in 1993. Owens, a graduate of LaSalle University in Pennsylvania, worked in Bakersfield, California, for eight years before coming to Harrisburg in 1993. Owens is presently coanchor of ABC 27's *News at 6*. (Courtesy of WHTM.)

Chuck Rhodes became a feature reporter for WHTM in 2008 after 35 years as a weather anchor. Rhodes started at WHTM (then WTPA-TV) in 1973. After serving in the US Navy, Rhodes earned a bachelor of arts degree in radio and television broadcasting from Penn State University in 1972. Rhodes was voted Top Television Personality and Favorite Weather Forecaster in *Harrisburg Magazine* and briefly appeared in the film *Lucky Numbers*. (Courtesy of WHTM.)

Alicia Richards from ABC 27 (WHTM) graduated from Southern Methodist University. She worked at stations in Sherman, Texas, and Cedar Rapids, Iowa, before coming to Harrisburg in 1994. Richards has interviewed First Ladies Laura Bush and Hillary Clinton. She also produced a series about lifesaving procedures used by a team of doctors from Penn State Hershey Medical Center who traveled to Ecuador. (Courtesy of WHTM.)

The "glam band" Poison played at Hershey Park Stadium in July 2002. Pictured from left to right, Ed Coffey, John Butler, and Amy Warner from 93.5 WTPA were on hand before the concert. For Poison, playing at Hershey was something of a homecoming for band members Bret Michaels and Rikki Rockett, who grew up in the suburbs west of Harrisburg. Poison was originally known as "Paris" in the early 1980s while playing the Harrisburg club scene. (Courtesy of Chris James.)

Pictured here are 99.3 KISS FM (WHKF) air personalities "O.C." Kearney (left) and Mike Miller. Kearney, who hails from Raleigh, North Carolina, held several announcing jobs in the South prior to coming to Harrisburg in 2007. Miller was born outside of Philadelphia and moved to Lancaster at age six. Except for a brief diversion to a station in Portland, Oregon, Miller has been with KISS since 2001. (Courtesy of WHKF.)

Michael Parks is a Harrisburg radio veteran. He started at WKBO in 1983, and by 1985, he was writing and producing commercials at WCMB-WSFM. Since then, he has served in several creative services and production capacities for local stations. He is heard frequently on the River, BOB, KISS, WHP (AM) and WTKT. He also hosts a Saturday morning talk show on WHP (AM). (Courtesy of Michael Parks.)

Michael Moore (left) paired with Nancy Ryan on WRBT (BOB 94.9) in January 2001. When station programmer Shelly Easton needed a new partner for Ryan in late 2000, she initially confused Moore with another personality who used the same air name as Moore. Moore made such a good impression that he landed the job anyway and became the "new man" of the *Nancy and Newman* morning show. (Courtesy of WRBT.)

Chris Tyler, operations manager of the River 97.3 (WRVV) came to Harrisburg in 1992 by way of WSNI in Philadelphia. Tyler was born in northern New Jersey. After relocating several times, his family eventually settled in suburban Philadelphia. He landed his first job while attending the Newhouse School of Public Communications at Syracuse University, after which he worked in Buffalo, New York, and Columbus, Ohio. (Courtesy of WRVV.)

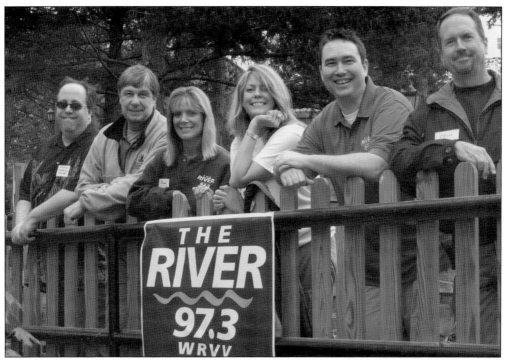

Pictured here are River air staff at Hershey Park in May 2008. From left to right are Michael Anthony Smith, Chris Andree, Dina Joseph, Jeni Gipe, Glenn Hamilton, and Chris Tyler. The River has been one of the highest-rated radio stations in central Pennsylvania since 1992. A number of the bands featured on the River have appeared in Hershey, including the Who, Bruce Springsteen, Bon Jovi, and Aerosmith. (Courtesy of WRVV.)

Photographer J. Alex Lang took this astonishing time-lapse picture in 2008. In the photograph, multiple lightning strikes can be seen hitting WITF's tower, located on Blue Mountain north of Harrisburg. As intense as the storm appears, countless lightning strikes hit this tower every year with little or no recorded damage. (Courtesy of J. Alex Lang.)

www.arcadiapublishing.com

Discover books about the town where you grew up, the cities where your friends and families live, the town where your parents met, or even that retirement spot you've been dreaming about. Our Web site provides history lovers with exclusive deals, advanced notification about new titles, e-mail alerts of author events, and much more.

MADE IN THE

Arcadia Publishing, the leading local history publisher in the United States, is committed to making history accessible and meaningful through publishing books that celebrate and preserve the heritage of America's people and places. Consistent with our mission to preserve history on a local level, this book was printed in South Carolina on American-made paper and manufactured entirely in the United States.

This book carries the accredited Forest Stewardship Council (FSC) label and is printed on 100 percent FSC-certified paper. Products carrying the FSC label are independently certified to assure consumers that they come from forests that are managed to meet the social, economic, and ecological needs of present and future generations.

FSC
Mixed Sources
Product group from well-managed
forests and other controlled sources

Cert no. SW-COC-001530
www.fsc.org
© 1996 Forest Stewardship Council

Find Your Place in History.